Giovanna Magi

Masterpieces of the

LOUVRE

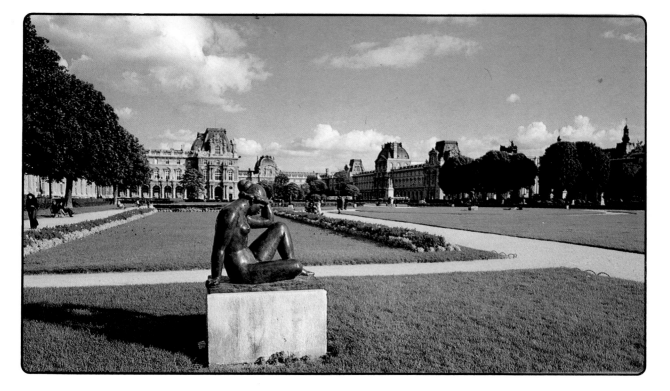

63 Color illustrations

BONECHI

*All the photographs
in this book were taken by*
JACQUELINE GUILLOT, Paris

Translated from the Italian by
MICHAEL HOLLINGWORTH

ISBN 88-7009-151-1

© Copyright 1988 by
CASA EDITRICE BONECHI
Via Cairoli 18/b
Firenze - Italy
Telex 571323 CEB

Printed in Italy

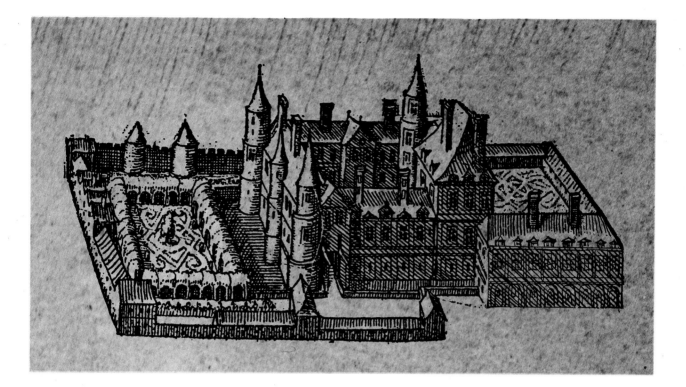

The Louvre dates back to 1200, when Philip Augustus had a fortress built near the river for defense purposes: it occupied more or less a fourth of today's Cour Carrée. The fortress was not, then, the royal residence (the king, in fact, preferred living in the Cité) but it housed, among other things, the royal treasure and the archives. In the 14th Century Charles V, the Wise, rendered the fortress more habitable and took it as his residence. One of his additions was the famous Librairie: this construction earned him the appellative by which he became known in history. After his reign the Louvre was not used as the royal residence again until 1546, when Francis I commissioned the architect Pierre Lescot to improve the residence and render it more in keeping with the new Renaissance tastes. He had the old fortress demolished: the new palace rose on its foundations. Work continued under Henry II. After his death, Caterina de' Medici entrusted Philibert Delorme with the construction of the Tuileries palace and a long wing reaching out toward the Seine to join it to the Louvre. Work, interrupted at Delorme's death, continued and was terminated under Henry IV, who had the Pavillon de Flore constructed. The enlargement of the edifice continued under Louis XIII and Louis XIV with the completion of the Cour Carrée, which, by merit of the richness of its sculptoral decoration, became the most prestigious part of the so-called Old Louvre, and with the construction of the east façade with the Colonnade. When the court moved to Versailles in 1682, work on the Louvre was almost totally abandoned; even the palace itself became so rundown that in 1750 it was thought to demolish it outright.

One may say that the women of the Parisian markets saved the Louvre when they marched on Versailles on October 6, 1789 to bring the royal family back to Paris. After the tumultuous years of the Revolution, Napoleon finally took up work on the Louvre again. His architects, Percier and Fontaine, began construction of the north wing. It was finished in 1852 under Napoleon III, who decided, finally, to complete the Louvre. With the fire and consequent destruction of the Tuileries during the siege of the city in May of 1871, the Louvre took on its present aspect.

Even though the name "Louvre" properly refers to the palace, it is today identified with the celebrated Museum. The collection of works there exhibited is so vast that the Louvre has often been defined "the world's most important museum." From an initial nucleus of works, the Louvre collection grew with the collections of the Kings of France; its continual expansion has since been assured by a wise buying policy and generous donations. Francis I is unanimously recognized as the founder of this important collection. The sovereigns preceeding him had commissioned and brought works of art—especially paintings—but until his time these were isolated episodes. Francis I (1515-1547) began a real and proper collection of all genres of works in order to enrich the royal residence at Fontainebleau. He will succeed in commissioning the most important artist of the times, Leonardo da Vinci, and thus in attaining ownership of some of Leonardo's most important works: for example, the "Monna Lisa" and the "Virgin of the Rocks." During the same period, works by such Italian

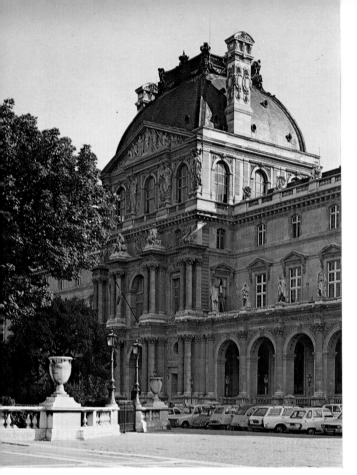

Pavillon Denon

authors as Andrea del Sarto, Titian, Sebastiano del Piombo, Raphael will become part of the collection. Francis I's successors will not show much interest in the collection of works of art. They will limit themselves to commissioning a few portraits by contemporary French artists: Clouet and Corneille, for example. A further impetus was given to the collections during the reign of Louis XIII: even though he was rather indifferent to artistic matters, his celebrated Minister, Cardinal Richelieu, was a true collector. At his death Richelieu left his collections to the Crown, whose holdings were thus enriched by such masterpieces as "The Pilgrims" by Emaus di Veronese and Leonardo's "Saint Anne." Maria de' Medici, the King's mother, also contributed to the growth of the collection: she ordered a certain number of canvases from Rubens for her new residence in Luxembourg. Nevertheless the collection was still relatively modest. An appraisal of the time counts 200 paintings.

With the successor, Louis XIV, the collection will make some really important progress: it is enough to recall that, at the time of his death, the "Royal Collection" counted over 2000 paintings. First the king was wise enough to buy, at his Minister Colbert's suggestion, a part of Cardinal Mazarino's collection. He then had the great good luck to be able to buy the collection of Charles I of England, which Cromwell had put up for sale. This collection was very important in that it had previously absorbed the collections of the Mantuan Gonzaga

princes. The Sun King, moreover, will collect numerous works by such French authors as Poussin, Lorrain, Le Brun, Mignard. His successor, Louis XV, was not as capable. Only a very few works by deceased artists will enrich the collection; nevertheless, he will purchase numerous works by such contemporary authors as Chardin, Desportes, Vernet, Van Loo, Lancret. Under Louis XVI numerous works by 17th Century Italian artists were acquired: these came from Amedeo di Savoia's collection, dispersed with the Succession. During Louis XVI's reign attempts will be made to enact the new cultural proposals with regard to art. These ideas had already been advanced under his predecessor; the idea of opening the royal collections to the public was constantly heard. Already in 1749 an exhibition of a limited selection of the works was opened in the Palais du Luxembourg. Diderot had explicitly asked, in 1765 in the Encyclopaedia, that the Louvre be used for the exhibition of the works contained in the Royal Collection. This turmoil was heard by the "Constructions Director" Count d'Angiviller, who planned the "Grande Galerie" especially for this purpose. Moreover, he filled in some of the gaps in the collection: he completed the representation of French authors and purchased numerous works of the Flemish school. Nevertheless the project was still incomplete at his death: only the Revolution will finally put it into effect.

In 1792 the revolutionary government decided to transfer the Royal Collections, now property of the Nation, to the Louvre. The "Central Museum of Art" opened on August 10, 1793, with the presentation of a selection of 687 works. New works, confiscated from churches, noble families and abolished local administrations, will come to the Louvre in this period. Under Napoleon, the Museum will be enlarged and transformed. The Department of Greek and Roman Antiquity will be formed; the archaeological collections will grow. Nevertheless, the Egyptian Antiquities Department will not be founded until 1826. The Emperor established a system of acquisitions which, although it seems highly criticizable today, was at the time considered not only admissible but even "glorious." He "requisitioned" works of art from the conquered countries and sent them to the Louvre (then called "Napoleon Museum"): an enormous number of works was directed toward France from Belgium, Holland, Germany, Austria and Italy. This will prove, however, to be a short-lived enlargement: by the end of 1815 about 5000 of these works will have been returned to their legitimate owners. Nevertheless, thanks to various agreements and particular exchanges, and also to certain subterfuges, a hundred or so works will remain in Paris. In the 50 years following expansion will center on the Oriental collections: the Assyrian Collection will profit from Botta's expedition, the Egyptian Collection from the illuminated guidance of Champollion, the decipherer of hieroglyphics. Other important additions to the collection will be made under Napoleon III: the purchase of the Campana collection and the acquisition of the La Caze bequest containing enormously important works by Watteau, Fragonard, Chaudin, Hals. Although there have been no more clamorous acquisitions of large groups of works, new purchases have constantly enlarged the collections since that time. Nor must we forget the great merit of the numerous patrons of the arts who will donate their collections to the Museum. The Museum's catalogue today counts about 400,000 single works divided among the various Departments of the Museum.

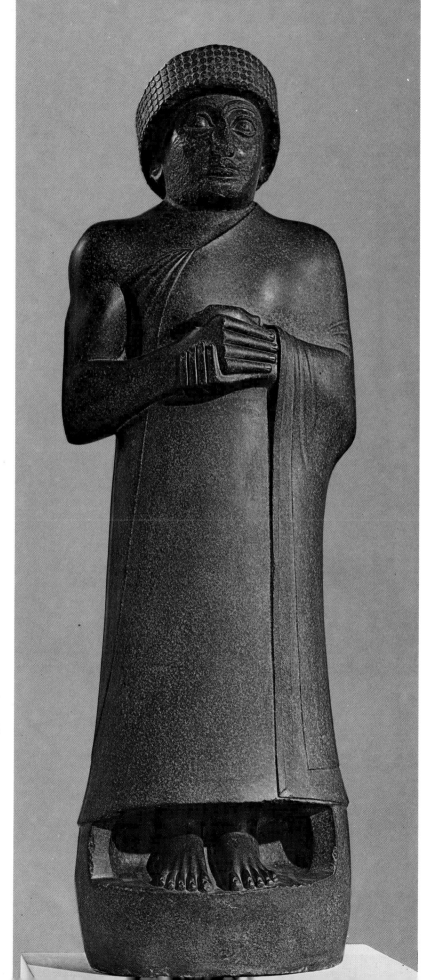

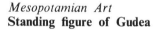

Mesopotamian Art
Standing figure of Gudea

Among the extant neo-Sumerian statues, which stylistically are a continuation of the preceding period under the dynasty of Akkad, are about 30 works depicting Gudea, the " patesi " of the city of Lagash. The Sumerians used the name " patesi " to indicate a dignitary who occupied both a political and religious position: Gudea refused the title of king and would accept only this designation. Most of the statuettes were found during excavations by the French at Tello. Gudea is depicted in both sitting and standing positions, but in each work his hands are joined in the act of prayer. This is one of the most famous and finest of the statuettes because of its simplicity and intense religious spirit; made from dolerite, it is 41 inches high. The figure has a typical Persian lamb's wool hat on the head and a simple cloak on the shoulders. Acquired by the Louvre in 1953, it belongs to the " high-dynastic " era, that is between about 2290 and 2255 B.C.

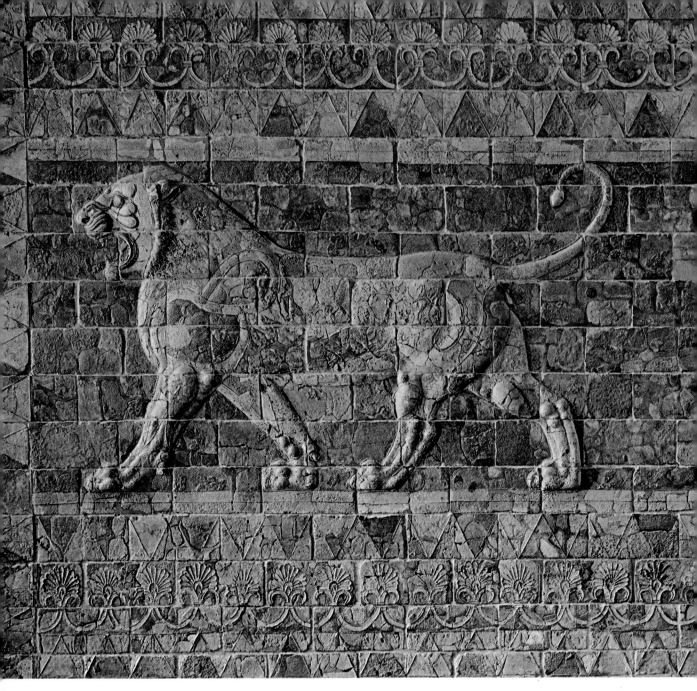

Persian Art
Lions

The art of Asia Minor frequently represented animals in its sculptural works, both in ceramics and in stone. These lions, whose feline pace has been successfully rendered with litheness and ease of movement by the unknown artist, come from the Imperial Palaces of Susa. Susa was, with Persepoli, one of the capitals of the kingdom of the Achemenedian Dynasty.

Persian Art
The King of Persia's Archers

These famous archers, made from enamelled brickwork (since Mesopotamia had very little stone, its buildings were constructed from bricks baked in the sun and then enamelled), are the so-called Immortals, the private guard of the King. The archers, each one 60 inches high, make up an endless procession covering the walls of the luxurious palace of Darius at Susa. The archers differ from one another in minute details, and this almost monotonous repetition of the same figure gives the impression of endless, uninterrupted movement. Their stately and dignified poses and the brilliant colours of their clothing make them a sort of hymn celebrating the greatness and might of the Persian Empire. They belong to the 5th century B.C., the time of the Achmenides dynasty, whose dominions extended for almost two centuries throughout the entire Middle East.

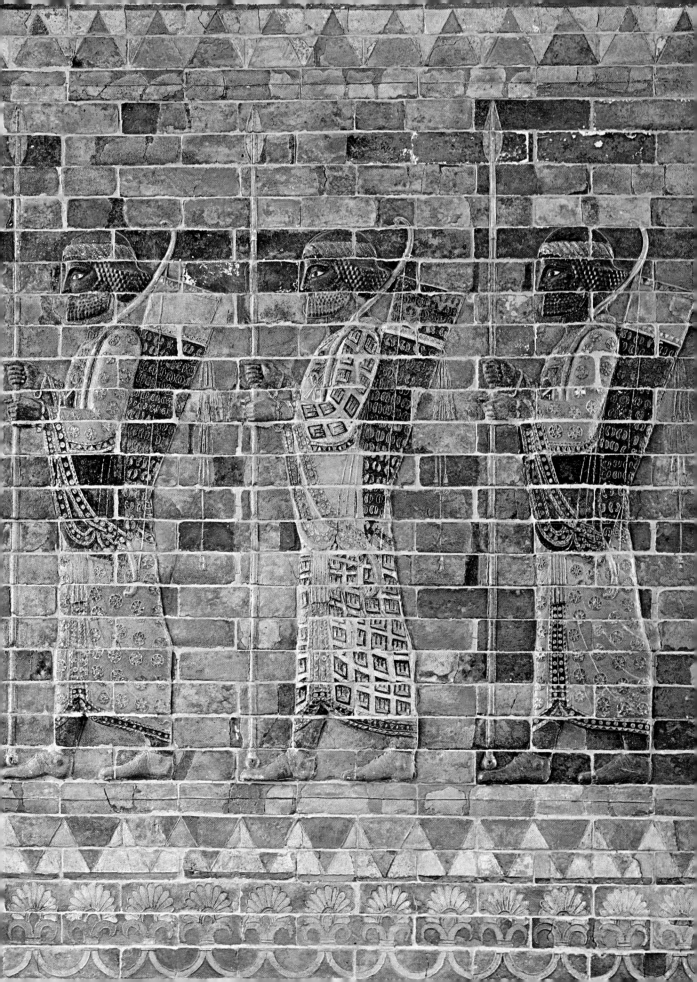

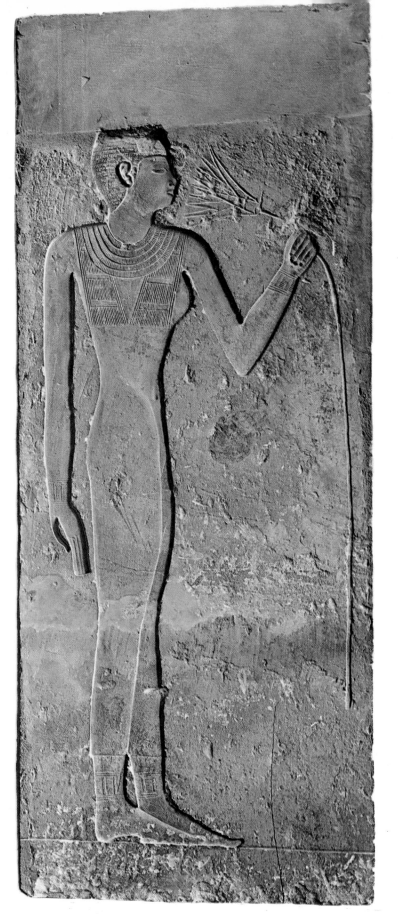

Egyptian Art
Maiden with Lotus Flower

The so-called "bordered relief" is one of the most common techniques used by the Egyptians to give life to their immortal masterpieces. Thus the figure with its enlarged border fairly leaps out, clean and precise, from the plane of the limestone slab: a young maiden sniffing a lotus, the flower dear to Egyptian iconography, represented in numerous sculptural and pictorial works. The relief is 1.27 meters high and belongs, perhaps, to the V Dynasty, under which art in Egypt reached extraordinary levels. The rigid geometry of the forms does not at all impede, even in this example, either the vitality or the naturalness that spring forth from this relief.

Egyptian Art
Seated Scribe

Found in 1921 near Saqqârah in an excavation project directed by Mariette, the Scribe is a masterpiece among Egyptian statues. It belongs to the Old Empire, that is to the time of the 5th Dynasty, and was presumably made in about 2500 B.C. It is 21 inches high and is made of painted limestone, with eyes of semi-precious stones: the cornea is of white quartz, the iris of rock crystal and the pupil of ebony. The Scribe's fixed stare, the rigidly geometric composition and the severely frontal stance of the massive figure are its most obvious features. At the same time, it is animated by an intense sense of internal life: the Scribe seems to interrogate the spectator with his eyes, ready to begin work on the roll of papyrus which rests on his knees.

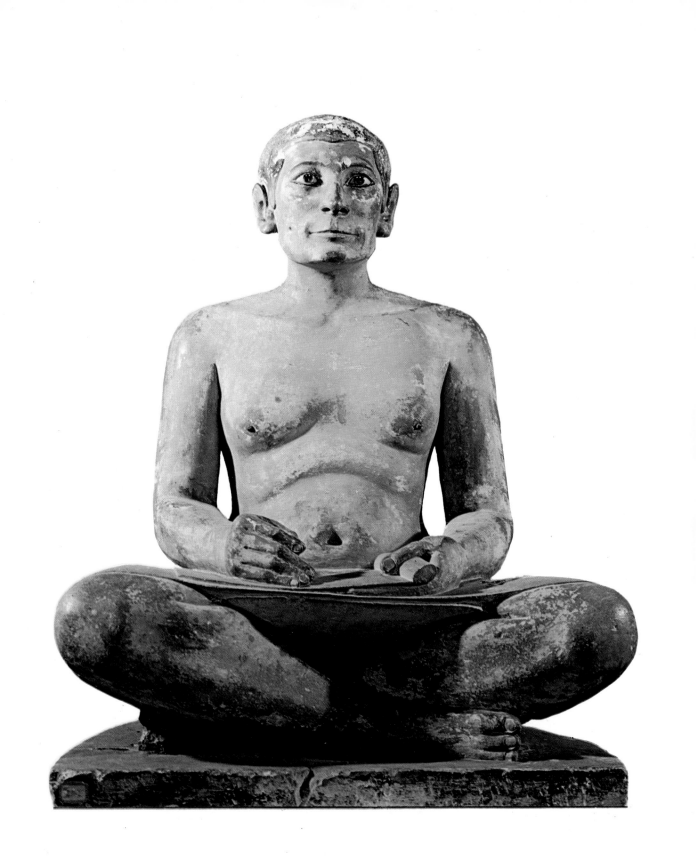

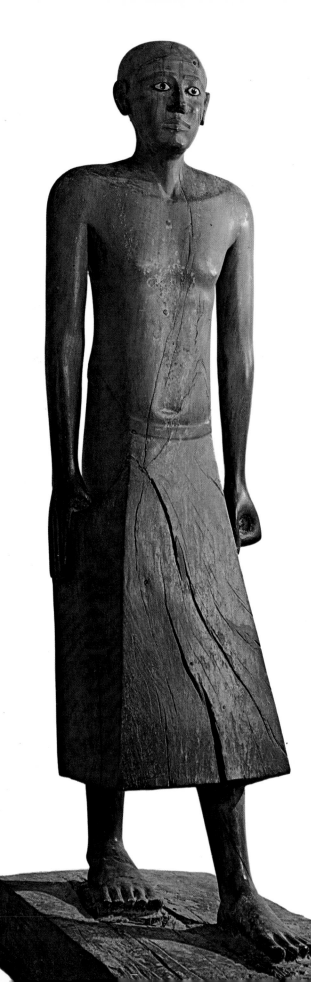

Egyptian Art
Statue of the chancellor Nakht

Found during the excavations of Assiut, this statue belongs to the Middle Kingdom at the time of the 13th Dynasty, when Egypt, under the rule of the energetic Theban kings, had a period of great power and prosperity. As a consequence, its art too was stimulated and went on to new conquests. This surprisingly realistic statue, made of wood on which can still be seen traces of the original colour, represents the chancellor Nakht. It is in a rigidly frontal position, although there is a hint of movement in the left leg which is slightly forward of the body. The almost nonchalant position of the right hand, hidden in a fold or pocket of the long cloak, gives the figure an unusually natural and spontaneous quality.

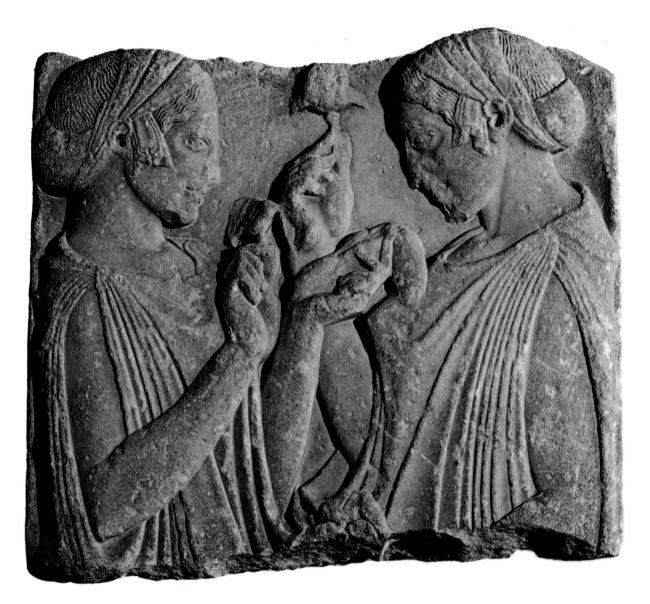

Greek Art
Exaltation of the Flower

Most of the works of Greek statuary have unfortunately been lost to us, and we know them only through late imitations and Roman copies. But in this room are exhibited original archaic works (dating, that is, from between the second half of the 7th century and the beginning of the 5th century B.C.). Outstanding among them for its beauty and elegance is this Exaltation of the Flower, in which can barely be seen the gentle smiles of the two maidens, from whose arms, linked as if in a dance, the flower and fruit of the pomegranate emerge.

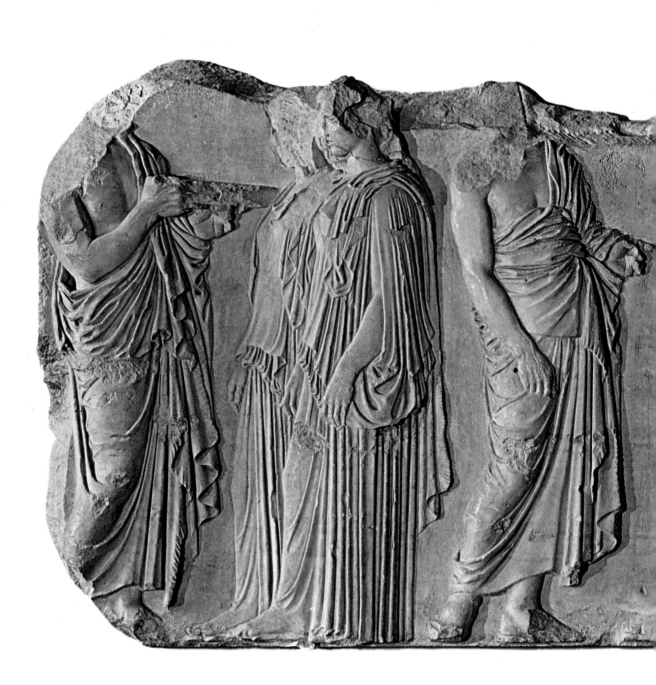

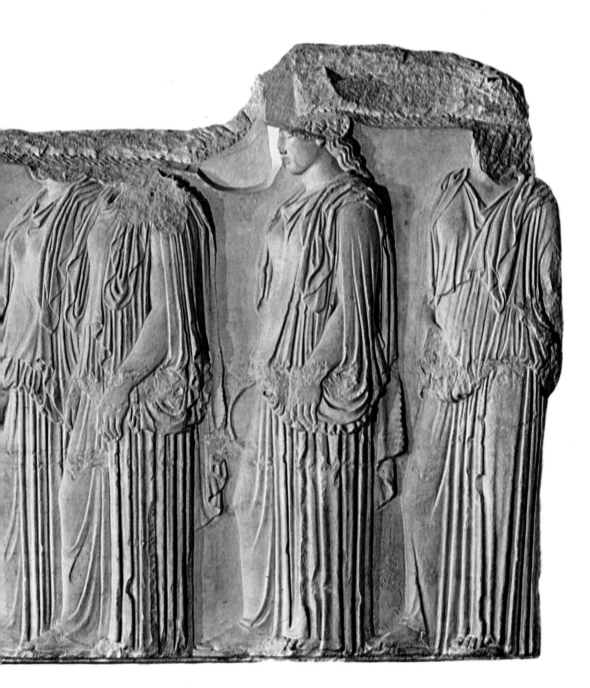

The most elevated expression of Ancient Greek culture and art (the Parthenon, on the Athenian Acropolis) must be ascribed to one of the greatest artists of all times: Fidia. The glory and the beauty of this temple are not determined solely by the elegant, symmetrical architectural elements, but also by the rich and exuberant plastic decoration: this last is today scattered all over the world. Fidia's "atelier" finished this frieze in the V Century A. C.: it ran around the naos of the temple, there depicting the annual procession during the celebration in honor of Athene, the patron goddess of the city. Even though dismembered and divided among various European museums (above all the Louvre and London's British Museum) the friezes lose nothing of their stylistic unity for being so fragmented: depth is never accentuated and is always equal for all the groups of figures, all of which emerge to the same degree from the background. The draperies, as well, while quite different one from another, all demonstrate an equal rhythm and the same cadence as the slow procession of maidens, the Ergastines, carry their hand-woven peplum to the goddess.

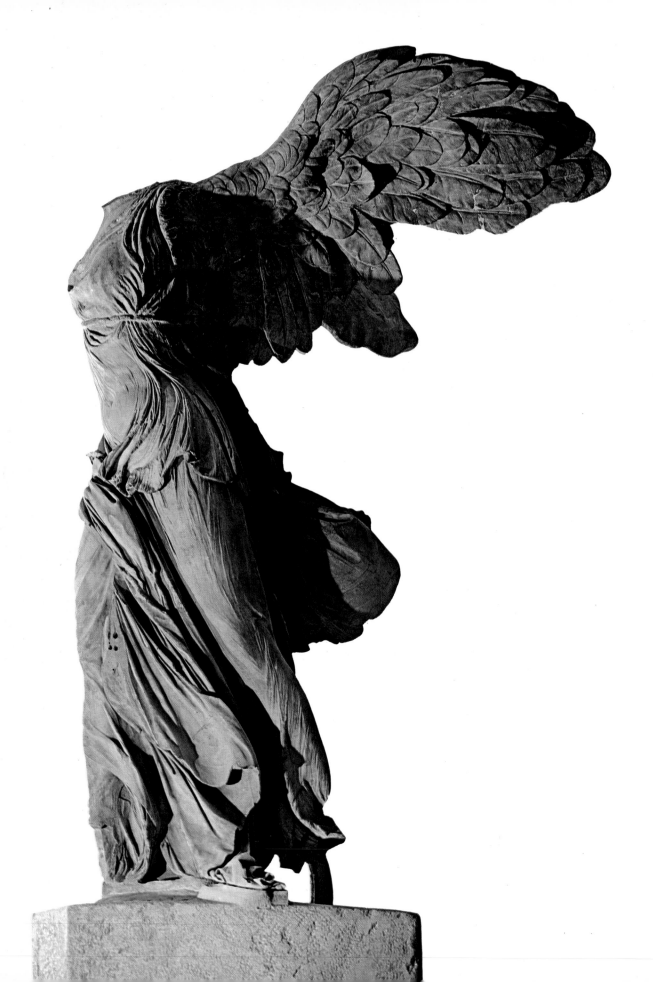

Nike of Samothrace

Found in 1863 at Samothrace, with
the head and arms missing (one
hand was discovered in 1950), this
work dates from about 190 B.C.,
a period when the inhabitants of
Rhodes had a series of military
victories against Antioch III. The
Nike (or Victory figure) stands erect
on the prow of the ship which she
will guide to victory: the sea wind
hits her with all its force, tearing at
her clothing and pressing it to her
body. The clothing here is treated
in an almost Baroque way (which
would fully justify the rather late
date assigned to the work): it vi-
brates in contact with the Victory's
body and flaps in the wind, which
in turn pushes the Victory's arms
violently backwards. About 9 feet
high and made from Parian marble,
this is without doubt one of the
most important works of the entire
range of Hellenistic statuary.

Venus de Milo

Discovered in 1820 by a peasant
on the island of Milo in the Cyc-
lades, this statue has come to be
considered the prototype of Greek
feminine beauty. Somewhat more
than 6 feet high, with its arms
broken off (no one has ever suc-
ceeded in establishing what the
original position of the arms was),
it belongs to the Hellenistic Age,
that is to the end of the 2nd cent-
ury B.C., but it almost certainly
derives from an original by Prax-
iteles. Like the other works by this
great sculptor, the figure is slightly
off balance, as if resting on an
imaginary support, which gives a
delicate curve and twisting move-
ment to the bust. Critics and art
lovers have long gazed on the
slender nude body of the goddess
emerging from the heavy cloth of
her cloak which is slipping towards
the ground. The material of the
statue itself, Parian marble, gives
the goddess's body and skin a
lightness worthy of the finest
classical traditions.

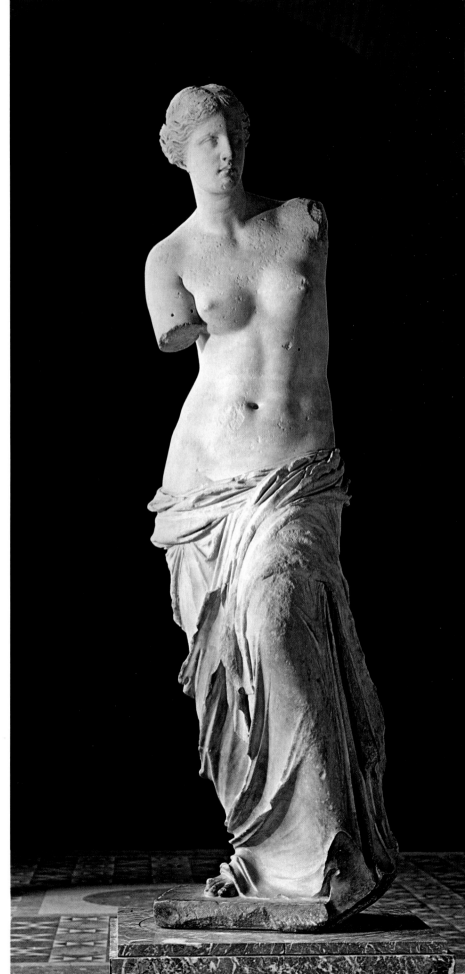

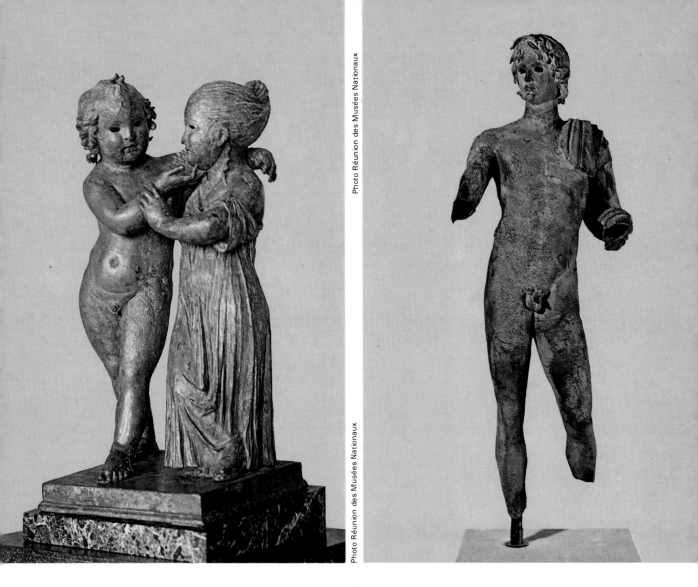

Photo Réunion des Musées Nationaux

Hellenistic Art
Eros and Psyche

This small, delightful sculpture of Eros and Psyche as children, discovered in the sea near Rhodes, stands at the center of the Bronzes Room.

The beloved myth of Eros (Cupid in Roman mythology) and Psyche fascinated ancient sculptors and painters. Eros had been represented by the Greeks since the most ancient epochs, and by the IV century B.C. had become a favorite theme of the artists.

In Hellenistic art the young God of Love takes on the form and the aspect of a plump, chubby young boy: he is often portrayed helping his mother Aphrodite out of her bath or playing with his father Ares' weapons. But it will be, above all, the sculptural group of Eros embracing Psyche which will find the greatest favor: it will be widely represented during the whole of the Roman period and will eventually acquire a symbolic value.

The story of Eros, the youngest of the Gods, as recounted by Apuleius in his *Metamorphoses,* is common knowledge. The God loves Psyche, a mortal maiden, but a condition is set: she must never try to look upon his countenance. While Eros in sleeping, Psyche lifts the veil that hides his face and is dazzled at her lover's beauty. Eros is taken off to Olympus for having broken the promise. Only later will Psyche, desperate at having been abandoned by her lover, be pardoned and ad-

mitted to Olympus to join the company of the other Gods.

Roman Art
Ephebus of Agde

This bronze statue from the Roman epoch, representing a young man, is known as "Ephebus of Agde." It was discovered in 1964 at Agde, a small city in southern France, in the Départment of Hérault, founded between the VIII and the VII centuries B.C. by Rhodian peoples. This greatly realistic statue unites volumetric compactness and a solid plasticity of unquestionably Etruscan origin with that tendency toward idealization that is clearly a legacy of the great Classical Greek tradition.

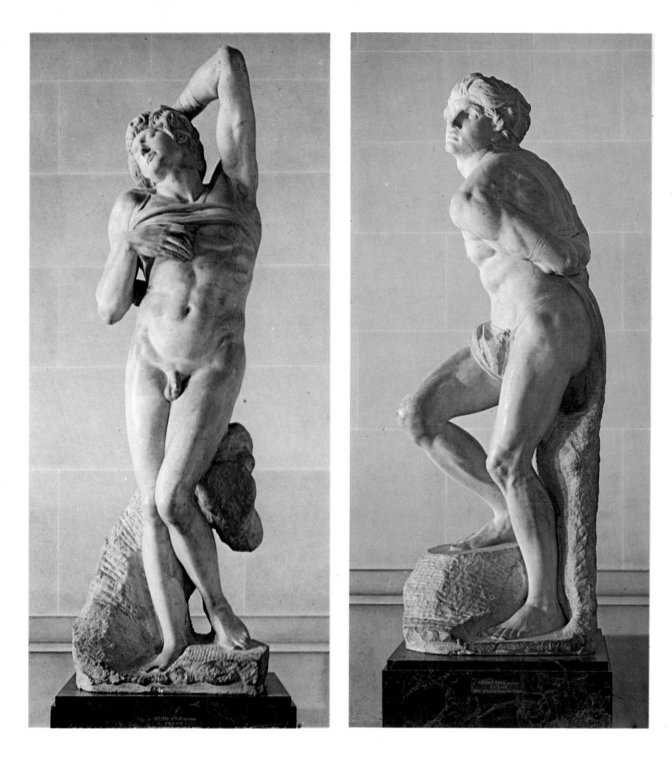

Michelangelo (1475-1564)
Prisoners

Sculpted between 1513 and 1520 for the base of the tomb of Pope Julius II (which was never completed), these statues were given to Henry II of France in 1550 by the Florentine exile Roberto Strozzi. Later they were transferred to the castle of Anne de Montmorency, at Ecouen, and then to that of Richelieu, finally reaching Paris where they came to the Louvre at the time of the Revolution. In Michelangelo's symbolic terms, they were perhaps meant to represent the Arts, imprisoned by Death after the death of the pope who had for so long been their protector. Above all, however, they are the clearest and most powerful expression of the restless, tormented spirit of Michelangelo in his unceasing effort to dominate the material of his art.

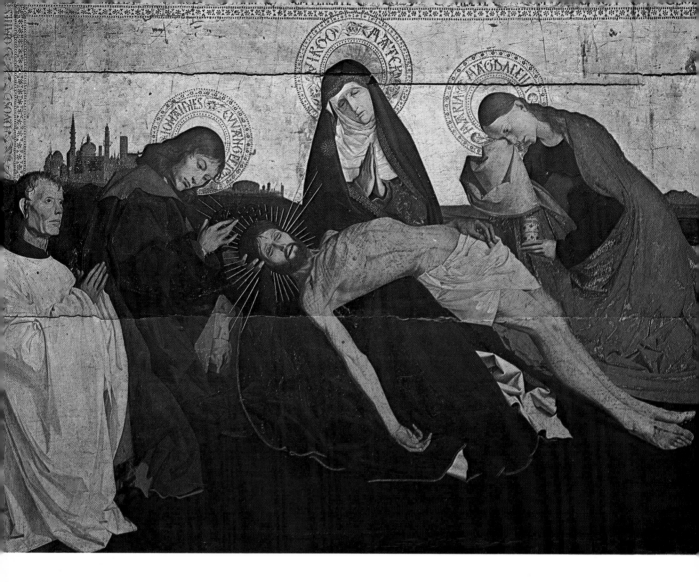

School of Avignon
Villeneuve-lès-Avignon Pietà

This splendid panel, a genuine masterpiece of the Gothic International style, saved from a fire in 1793 and rediscovered in 1801 in the church of Villeneuve-lès-Avignon, has long presented a problem as to both its dating and attribution. Some critics have advanced the name of Enguerrand Quarton because of certain iconographical details, while others have said that it is the work of a Spanish painter, if not actually derived from Van der Weyden. The group stands out powerfully against the gold background which is the last remaining heritage of the Gothic style and will soon be replaced by compact blue skies. The figures seem to be derived from the numerous Pietà sculpted in ivory, wood and stone. The colour contrast is splendid, while the body of Christ is abandoned on the knees of the Virgin and St. John, his face remarkably expressive, removes the thorns from Christ's head. According to some critics, the figure on the left of the panel, representing the donor, is the canon Jean de Montagnac. A strong sense of pathos and profound emotion is created by the horizontal line of Christ's body, which tragically interrupts the static and compact group surrounding it. The sure sense of design and above all the expression of dignified grief seen on the faces of the figures make this panel one of the masterpieces of French painting.

Jean Fouquet (c. 1420-c. 1480)
Portrait of Charles VII, King of France

This painting, hung in the Salon Carré where the marriage of Napoleon I and Marie Louise was held in 1810, is a justly famous work by Jean Fouquet, and seems to have been done in about the year 1444, that is shortly after the painter's trip to Italy. The painting was given by the king to the Sainte Chapelle of Bourges, where it may have remained until 1757, the year in which the church was demolished. It entered the collection of the Louvre in 1838. It offers a three-quarter view of the king, richly dressed and standing out clearly against the background.

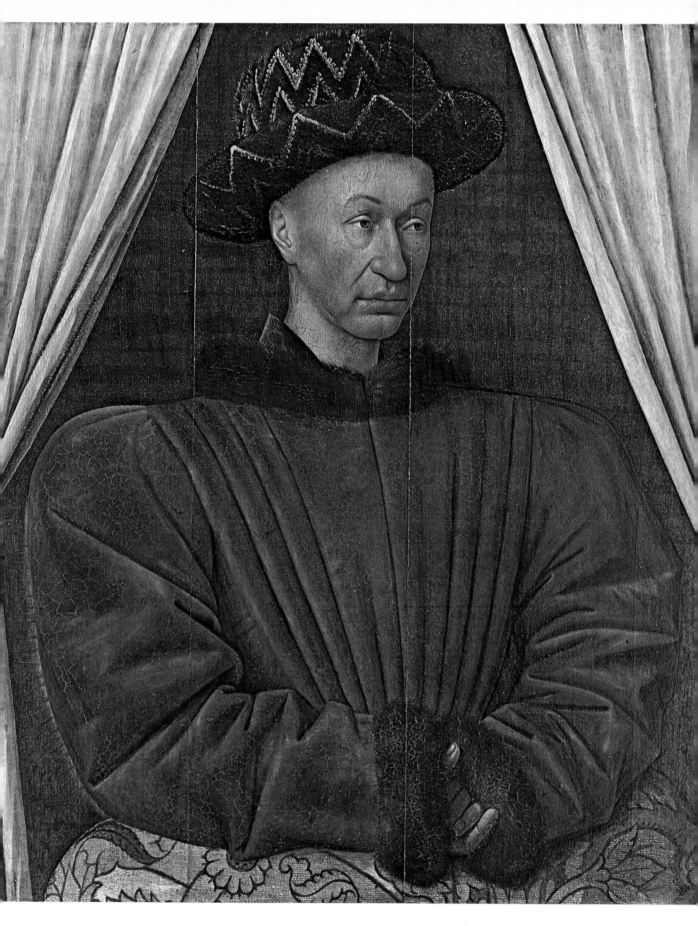

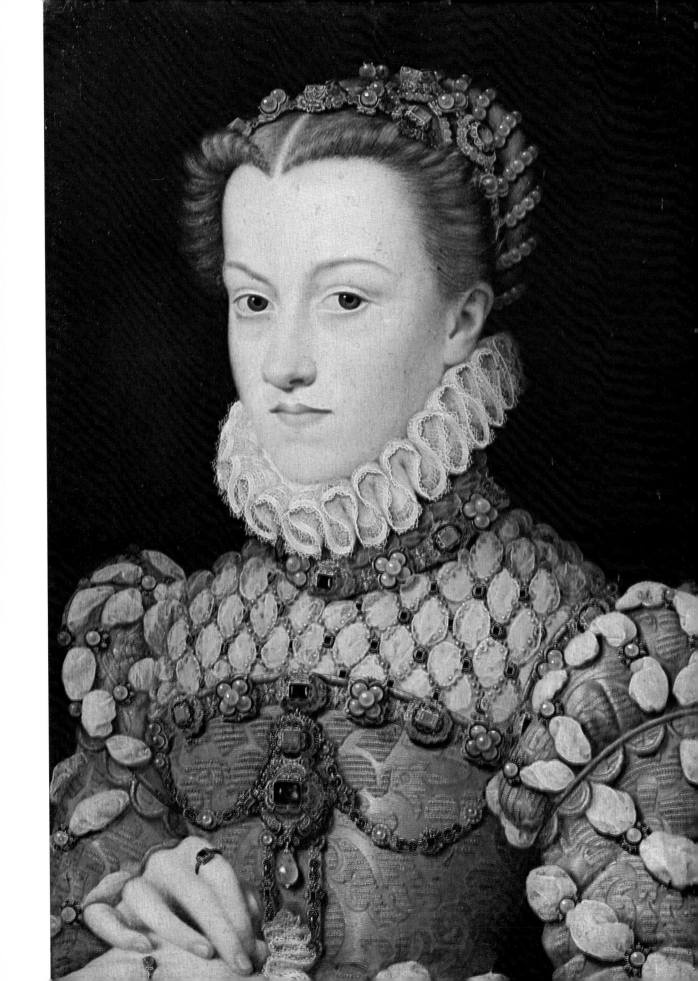

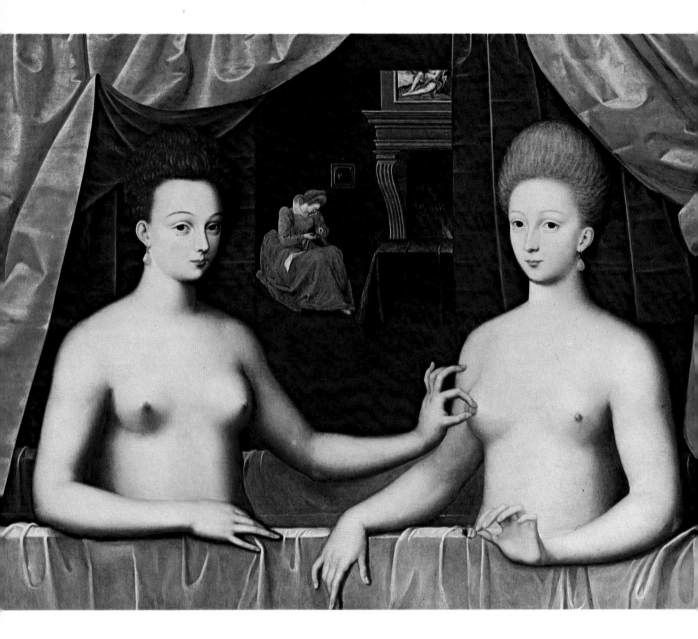

François Clouet (mentioned 1536-1572)
Portrait of Elizabeth of Austria

Son of the other great painter, Jean Clouet, François succeeded his father as court painter in 1540. In this portrait, painted with a sure mastery of line and a particularly delicate use of colours, the artist depicted the daughter of the Austrian emperor, Maximilian, who on 27 November 1570 married the king of France, Charles IX.

School of Fontainebleau
The Duchess of Villars and Gabrielle d'Estrée

The unmistakeable style of Clouet is fairly obvious in this work, attributed to the School of Fontainebleau, which can be dated at around the years 1594-1596. This is another example of the portrait, a genre which by then had become a fashion much patronised in court circles. Between the heavy curtains behind the two women a glimpse of domestic life is given: a woman sitting beside the fire, busy with her sewing. The two female figures, whose portraits have been painted while they are taking a bath together, are two sisters, Gabrielle d'Estrée and the Duchess of Villars. The latter, with a symbolic gesture, is announcing the future birth of the son of Gabrielle, who was the mistress of King Henry IV.

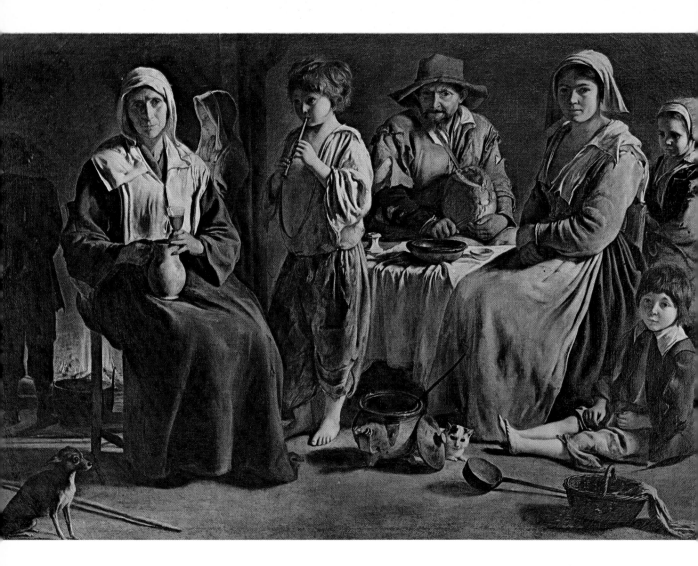

Louis Le Nain (1593?-1648)
Peasant Family

Of the three Le Nain brothers, Antoine, Louis and Mathieu, Louis is considered without doubt the best artist. A painter who specialised in portraying rustic scenes and lovingly recorded the world of the humble people, far from the luxuries of the court, he too displays in his work a distant echo of the luminous technique of Caravaggio, painting dark interiors with a minimum of illumination. But what was a metaphysical, supernatural light in Caravaggio is transformed in Le Nain's work into the quiet glow of the fireplace. The members of this poor peasant household seem

to have been posed in front of an imaginary photographer, each one having left off his normal activity. The painter, more than ever poetic in this work, captures the tiniest details of the room with affection and accuracy, dwelling on it with a feeling of lament for a pure and simple world.

Georges de la Tour (1593-1652)
Mary Magdalene with Oil-lamp

The artistic formation of George de la Tour, who was born at Vic-sur-Seille and died at Lunéville, was rather complicated. He preferred compact, closed volumes and a pure geometric style, forms im-

mersed in the shadows and revealed by skilfully placed rays of light. It is obvious that he learnt much from Caravaggio. According to some critics, the Caravaggio influence derived from a trip to Rome which the painter made around the year 1612 or 1613; other critics believe the technique came from the artist's contacts with the works of Gherardo of the Nights, another painter fascinated by the problem of light and shade which he resolved with surprising ability. This painting, done towards 1635 or 1640, is full of a sense of desperate solitude, expressed in the way Mary Magdalene stares abstractedly at the tiny flame, which seems to be consumed before our very eyes, and in her almost mechanical way of caressing the skull in her lap.

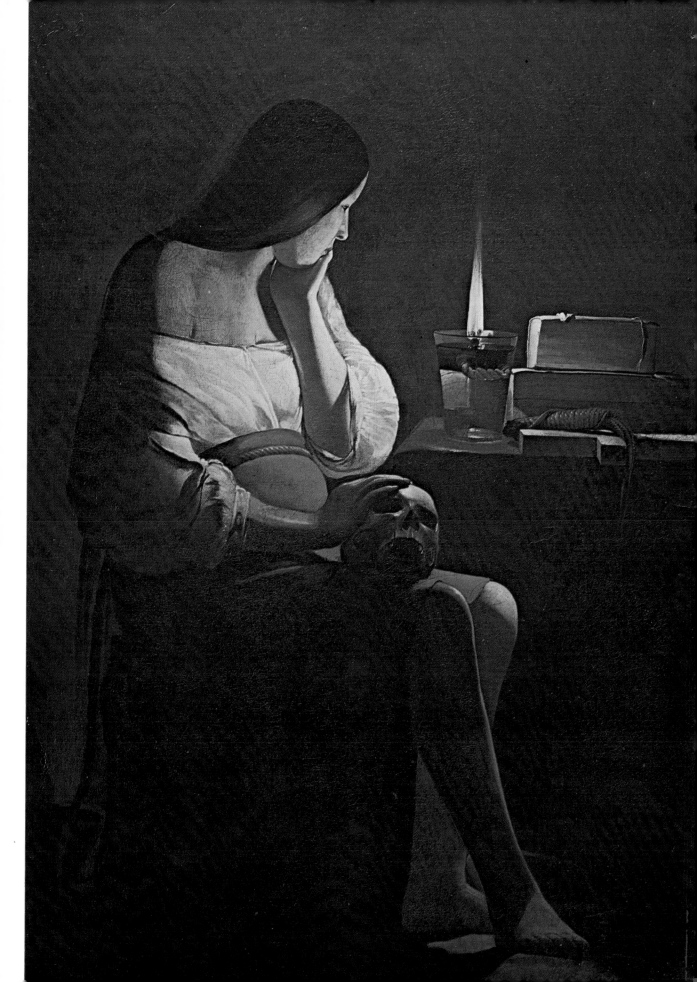

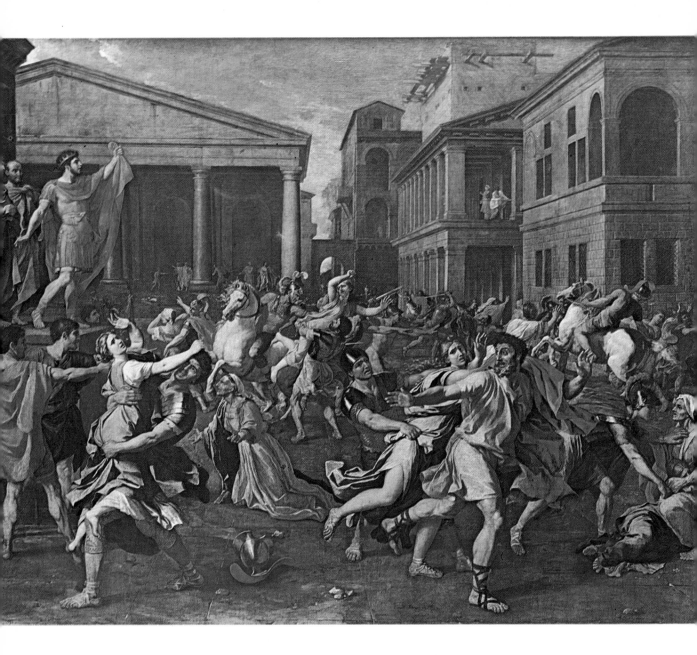

Nicolas Poussin (1594-1665)
Rape of the Sabine Women

Born in France, Poussin passed many years of his life in Rome, where he died. Here the painter came into contact not only with the Baroque world, which was slowly coming into being, but also with the world of the late Renaissance, which still survived in the works of Raphael in the Vatican.

Poussin preferred to paint large works of a mythological or historical sort, like this Rape of the Sabine Women, of which he also painted another version, now in the Metropolitan Museum of New York and datable at around 1637, that is some years after the work in the Louvre. Typical of Poussin's painting is the sense of agitation which can be felt between the figures, so strikingly framed in the motionless setting of classical architecture.

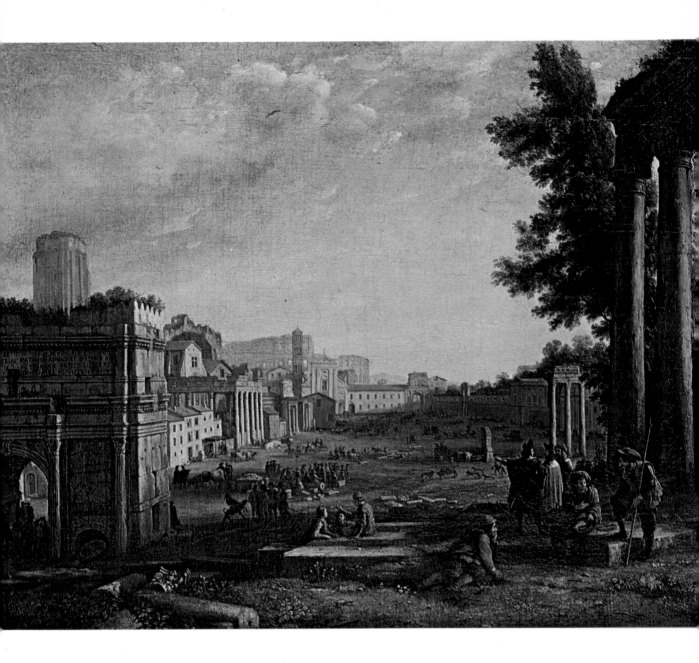

Claude Lorrain (1600-1682)
Campo Vaccino in Rome

Like Poussin, Claude Gellée, better known by the name of Claude Lorrain, also lived for many years in Rome. His Roman landscapes are full of a warm, golden light, typical of those sleepy afternoons when the shadows grow to enormous lengths on the rough terrain of the Roman Forum. With the eyes of one passionately interested in the antique world and its remains, Lorrain allowed his gaze to rest on a broken pediment, an arch covered at the top with moss, columns lying full-length on the ground, overturned capitals. His way of seeing nature and interpreting the landscape was thus completely different from that of Poussin.

Philippe de Champaigne (1602-1674)
Ex-voto dated 1662

Deriving from the Jansenist beliefs of the artist, this panel is painted according to the iconographical tradition of the ex-voto and represents the painter's daughter, Sister Cathérine de Champaigne, abbess of Port-Royal des Champs, as she is miraculously cured of paralysis after the prayers of Sister Cathérine Agnèse Arnaud. The event is described in the Latin epigraph on the left of the panel, and there is an air of mystic sanctity in the serene and dignified expressions on the faces of the two nuns. The painting, signed and dated, was done between 22 January and 15 June 1662.

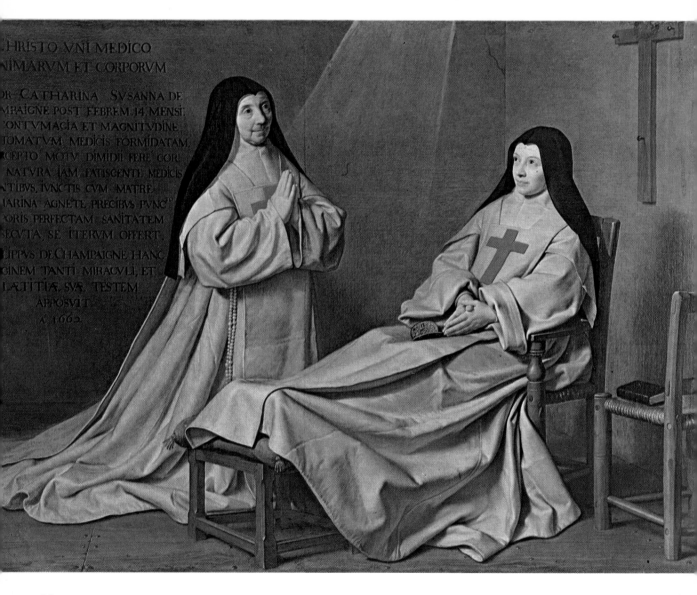

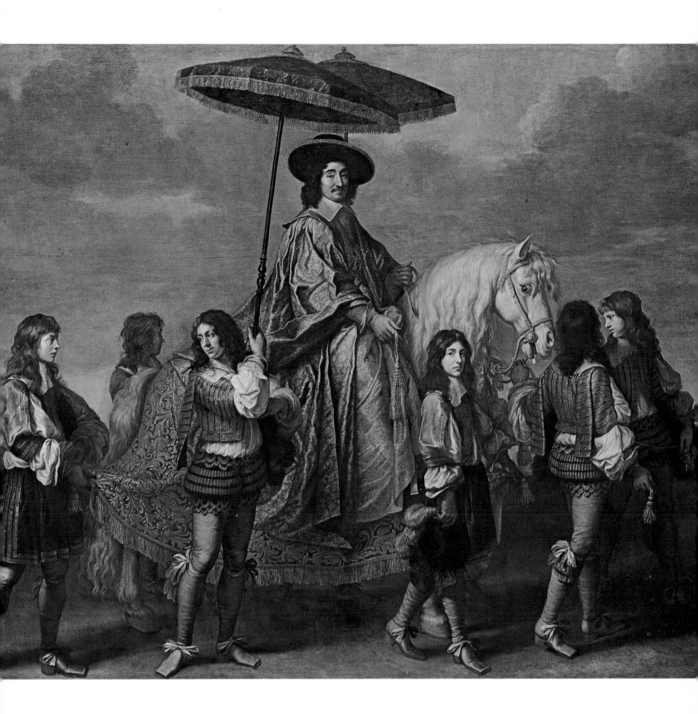

Charles Le Brun (1619-1690)
The chancellor Séguier

An architect as well as painter, Charles Le Brun was head of the French Academy during the reign of Louis XIV. In fact he decorated most of the Palace of Versailles and the sketches for its plastic decora-tions are also his work. His style clearly takes its inspiration from the Italian artists of the 16th century, in the richness and opulence of the clothing, in the stately quality of the poses and in the rich, warm colour. Here Le Brun has portrayed Pierre Séguier, Chancellor of France and the painter's patron during his youth. The painting may have been done towards 1655 or 1657.

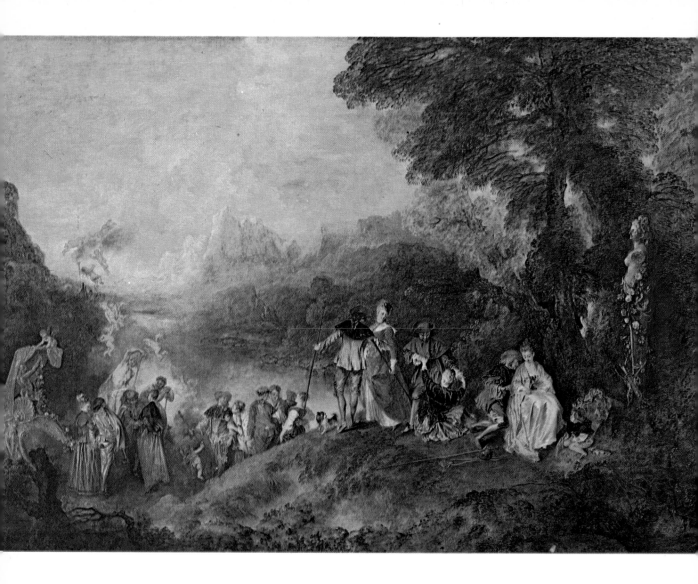

Antoine Watteau (1684-1721)
**Embarcation for the Island
of Citera**

This work of Watteau, difficult to
interpret and much discussed, was
presented at the Royal Accademy
on August 28, 1717: in 1795 it
became property of the National
Museum and later of the Louvre.
The interpretation of the canvas is,
as we have said, rather complex.
Some have seen a celebration of
Love, some the representation of
the games and customs current
with the elegant, refined society of
the Regency period. Watteau was
the supreme interpreter of this so-
ciety, representing as he did the
courting games, the pleasures and

the feelings of the various char-
acters with a coloring which, al-
though recalling the great Vene-
tian masters (above all Titian and
Veronese) is not certainly without
a suggestion of Rubens' robust
brushstroke.

Antoine Watteau (1684-1721)
Gilles

If Rubens is the highest expression
of the Baroque Age, Watteau is
without doubt his equivalent in the
era of Rococo. Rather than the
unleashed passions in the great
Flemish painter's work, Watteau

depicts an intimate, idyllic world.
Done around 1717 or 1719, this
work represents Gilles or Pierrot, a
character from the Italian Com-
media dell'Arte, and the figures
in the background also belong to
the popular theatre. The painting
was acquired in 1804 by Baron
Vivant-Denon from the art dealer
Meunier, who had it displayed as
a signboard for his shop in Place
du Carrousel. In 1869 it was be-
queathed to the Louvre. One critic,
Mantz, has suggested that the work
is a portrait of the comedian Bianco-
nelli. In any case, the painting is
striking because of the luminous
quality of its colour and the hu-
manity which can be seen in the
pathetic face of the comedian.

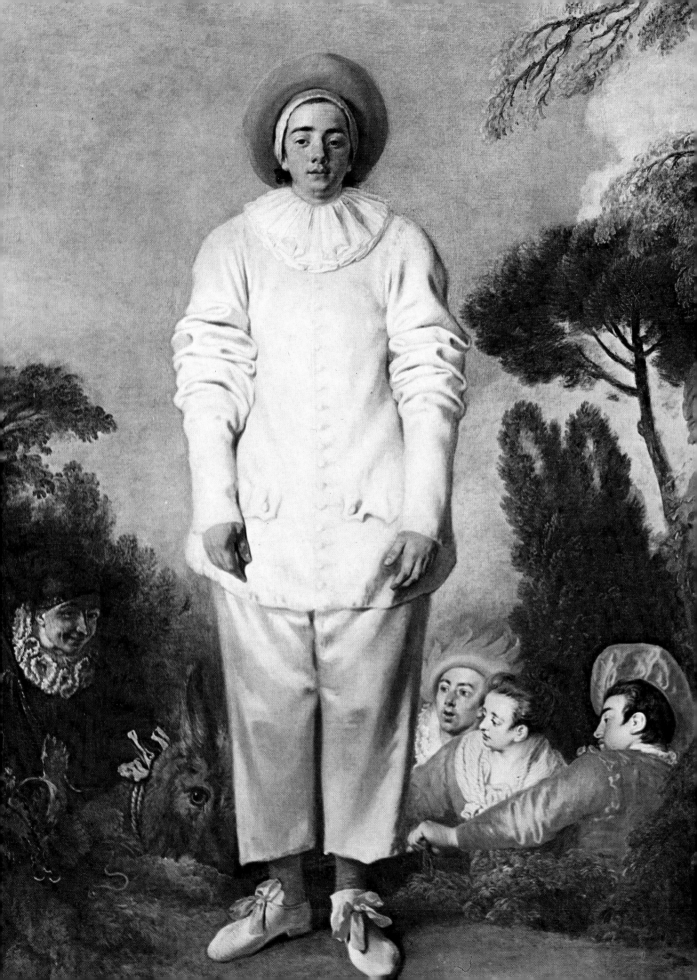

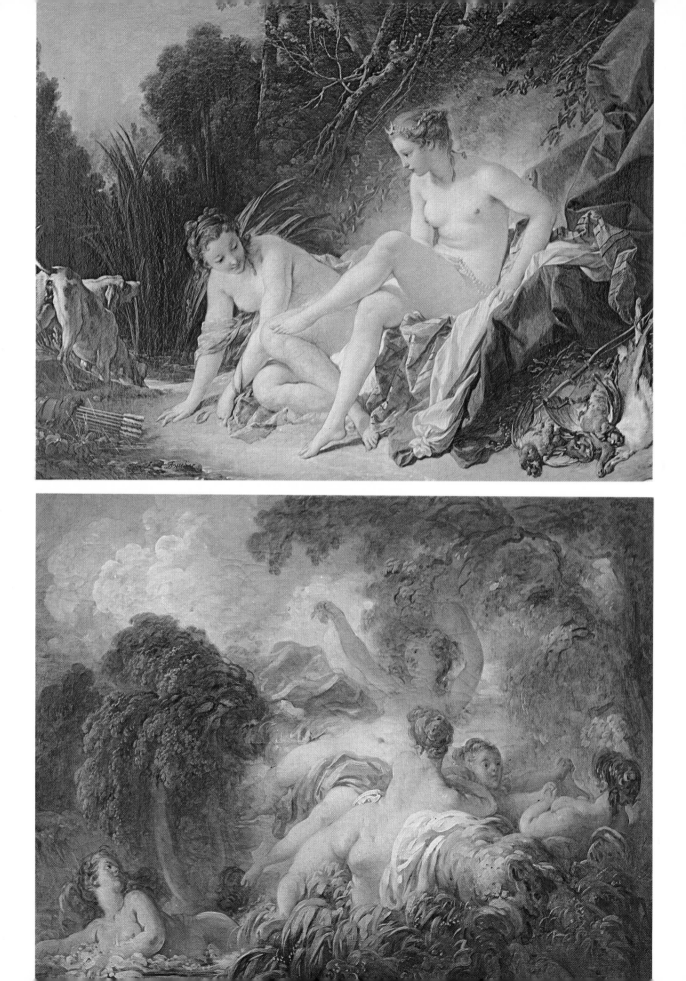

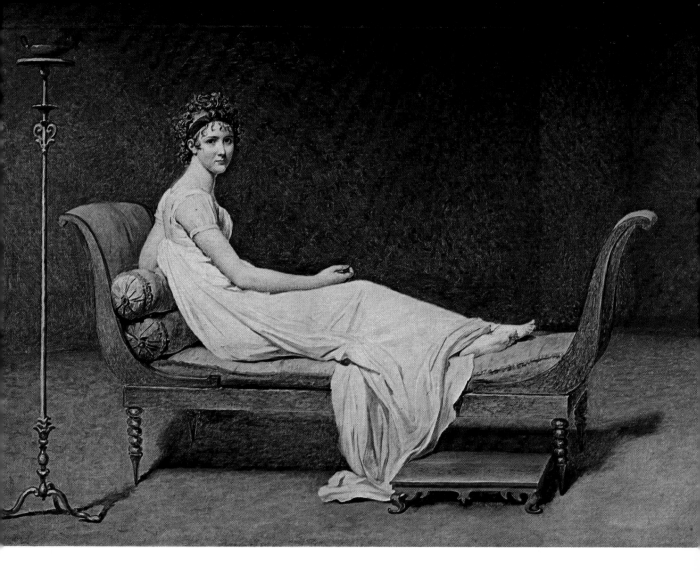

François Boucher (1703-1770)
Diana resting after leaving her bath

A typical representative of the French Rococo style, Bouchet was a court painter at the time of Louis XV and enjoyed the patronage of Madame la Pompadour. His is a festive, refined art, full of the joy of living. Rather than war-like divinities, he preferred painting more seductive figures from mythology, and this is why the many paintings of Venus which he left have been called « boudoir Venuses ". The female bodies which he loved to paint are perfectly proportioned, in the triumphant nudity of adolescence, warmed by his tenuous and delicate colours.

Jean-Honoré Fragonard (1732-1806)
The Bathers

Fragonard was the best-known and best-loved representative of French Rococo: a pupil of Boucher, he was greatly influenced by the style of Rubens in the sensual quality of his colour and the fullness of his forms. This canvas, perhaps painted in the period which followed the artist's first trip to Italy (from 1756 to 1761) and given to the Louvre in 1869, may have been done as a companion piece to the other work of the same subject, now part of a private American collection. The painting is a sort of hymn to life, sensuality and joy, but in forms which have become almost immaterial and ethereal.

Jacques-Louis David (1748-1825)
Portrait of Madame Récamier

This oil-on-canvas of Madame Récamier at age 23 is dated 1800: a period of David's production, that is, which is usually considered to be rhetorical and commemorative. His portrait painting, nevertheless, is an exception. This is an image of great purity, acute psychological introspection and warm humanity. The background is indistinct, intentionally dark so as to show up the beautiful figure of the woman as she delicately turns her head toward the spectator. Neither are the colors cold and metallic any longer: they have acquired a warm, intimate tone.

Jacques-Louis David (1748-1825)
Coronation of Napoleon I

With the coming of the French Revolution and the great changes which it brought in every field, artistic canons too were overturned. Rococo elegance was banished, and it was the Academy with its official tastes which now dictated the rules. The new era required its own interpreter and found him in Jacques-Louis David, who had been in sympathy with the revolutionaries and now became a fervent admirer of Napoleon, at whose side and under whose patronage he worked with great energy. After numerous sketches and drawings, David painted this enormous canvas with a surface of 580 square feet, representing the coronation of Napoleon which took place on 2 December 1804 in Nôtre-Dame. David worked on it from 1805 to 1807, with the help of his pupil Rouget as well, painting no less than 150 portraits, all of them vivid and solemn images. This work, which confirmed David definitively as the most important painter of the new Empire, displays an outstanding sense of equilibrium in its composition, besides solemnity and nobility of expression. One might say that each image and each figure (all historically recognisable) constitutes a portrait in itself because of the accuracy with which they are conceived and the coherency with which they are realised.

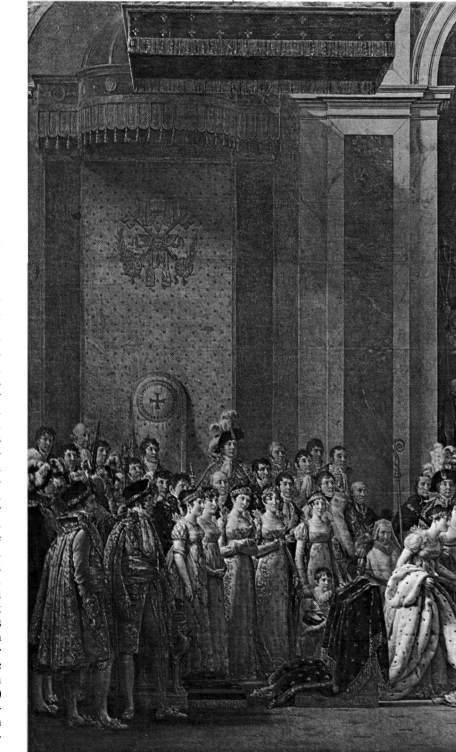

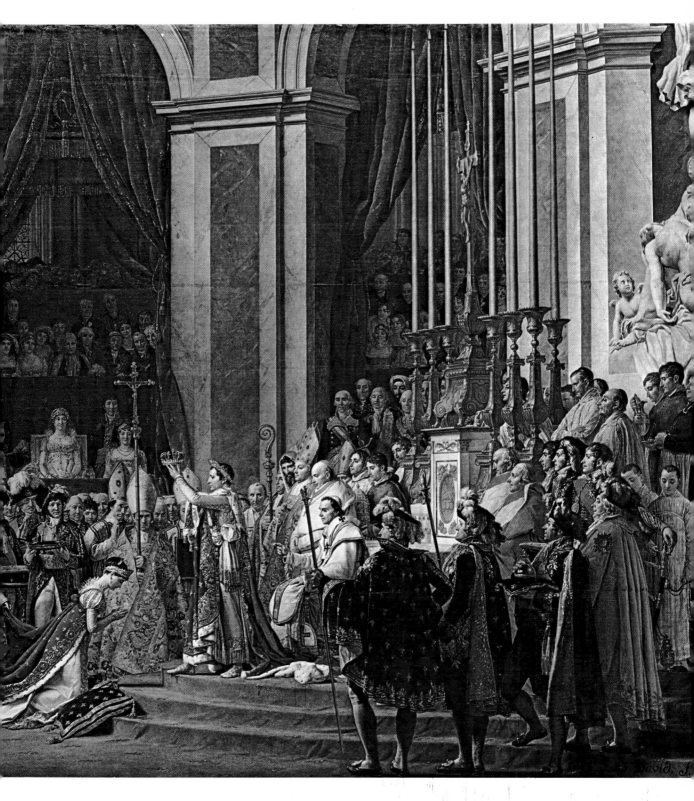

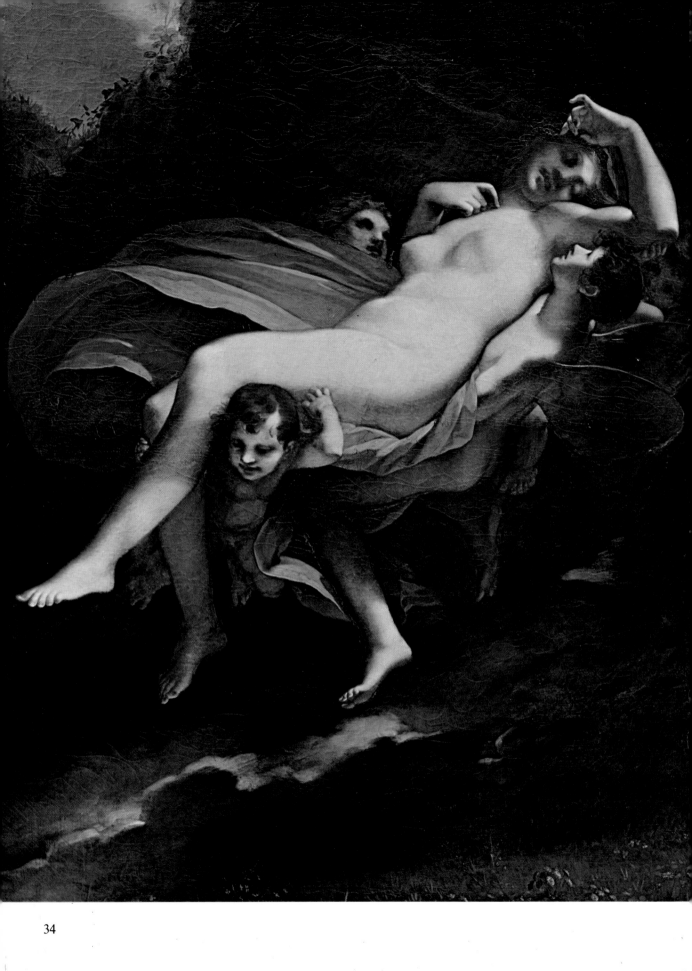

Pierre Paul Prud'hon (1758-1823)
The Rape of Psyche

As were many painters of his time, Prud'hon is of neoclassical formation: he feels the influence of 17th Century painting rather strongly. This work clearly recalls Guercino; more still, however, the slow, continuous movement of the forms, the sensuality of the composition and the contrast between the white of Psyche's body and the billowing yellow cape recall Correggio. Prud'hon, in rejecting the historical-rhetorical themes then in vogue in favor of allegory and mythology, is a precursor of Romanticism.

Théodore Géricault (1791-1824)
The raft of the Medusa

Painted and exhibited in the Salon in 1819, this canvas takes its inspiration from a tragic historical event: the " Medusa " was a French frigate which in 1816 was carrying settlers to Senegal when it was shipwrecked during a storm because of the inexperience of the captain. Most of the 150 passengers died; the few who were saved clung to a life-raft and drifted aimlessly in the immensity of the ocean, torn by episodes of human violence and ferocity. Géricault relates the story with a crude realism, to which the violent contrasts of light and shade, learnt without doubt from Caravaggio, contribute. Géricault captured on canvas the moment in which the shipwreck victims sight a sail on the horizon, and a tremor of life and hope seems to run through the raft which has known horror and death. The whole composition, with its diagonal line, presents a mass of interlocked, disjointed bodies and dramatic, hallucinated expressions. Truly splendid, the figure of the old man holding up a now dead body, absorbed in his grief and desperation (which are the same grief and desperation of all the others), as solemn and dignified as a figure from Greek tragedy.

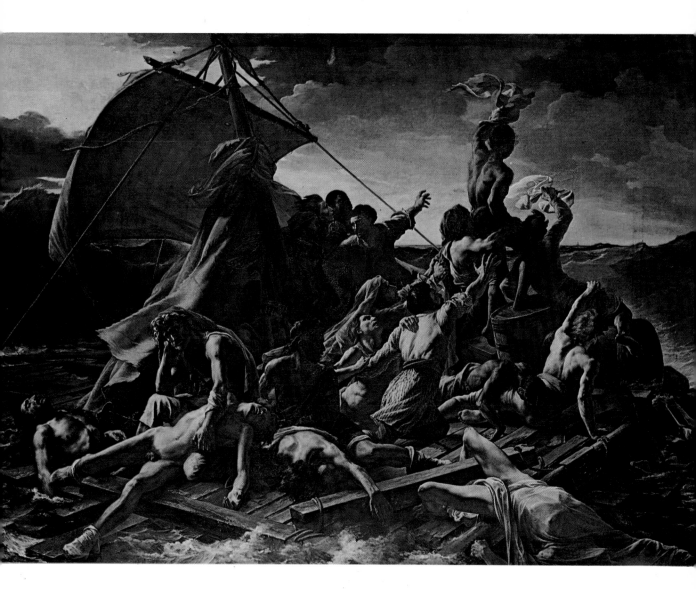

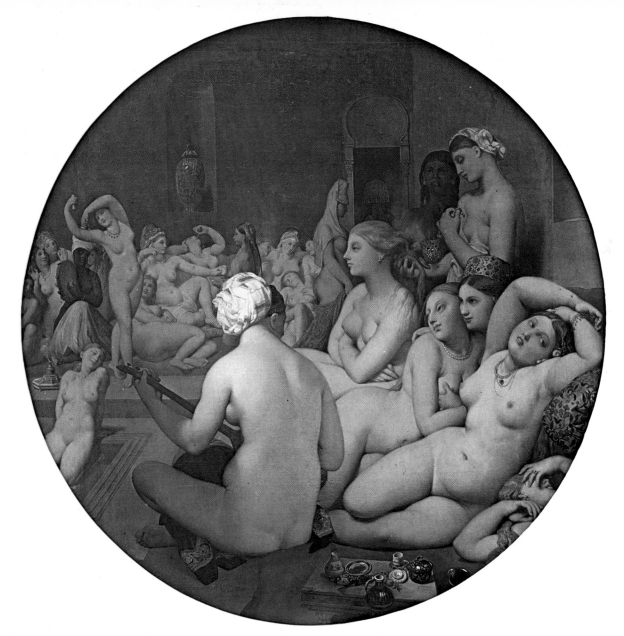

Jean-Auguste Ingres (1780-1867)
The Turkish Bath

This famous painting by Ingres, the inspiration for which certainly came from the description of a harem in the Letters of Lady Montague, was originally framed and was the property of Prince Napoleon. On the insistence of his wife, who considered the picture unbecoming because of the large number of nudes which it contained, Napoleon in April 1860 returned the work to Ingres who kept it in his studio until 1863, working on it continually and modifying it in various ways, one of which was to change it into a tondo. The Turkish ambassador in

Paris, Khalil Bey, bought it for 20,000 francs, and later it came into the hands of Prince de Broglie, finally reaching the Louvre in 1911. The painting can be considered a synthesis of all the experiences which Ingres had begun sixty years before: the drawing technique has become extremely slender and sinuous, the colour limpid, almost dazzling. A continuous line unites all the bodies to each other, immersed as they are in their sensual surroundings with a heavy atmosphere of Oriental perfumes. The nude bodies of the women, although they are highly abstract, are touched by an emotional tremor which renders them extremely natural.

Camille Corot (1796-1875)
Woman with the Pearl

Painted in 1868 in the same pose as Leonardo's Mona Lisa, this splendid figure of a woman is something of a prototype among the portraits by Corot: the line is sure and confident, the figure is immersed in a calm light and there is a sense of peace and serenity, features which are typical of all the works by the great French painter, both his portraits and landscapes. It has been said of his art that he had the same way of looking at both men and nature, and indeed Corot approaches humanity and the material world with the same sincere feeling of respect and liking.

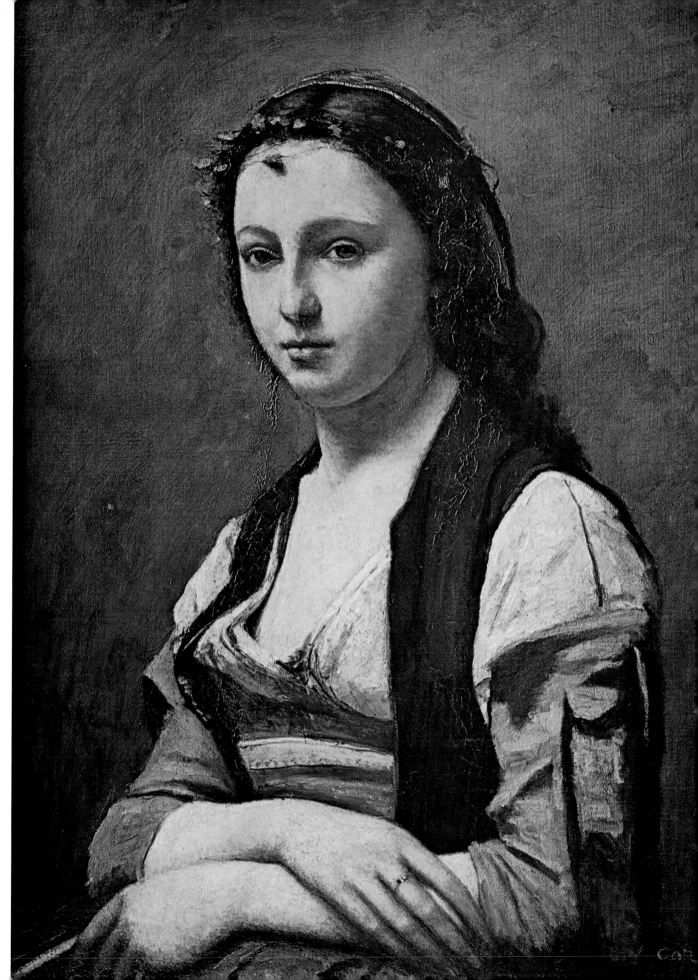

Eugène Delacroix (1798-1863)
Liberty leading the People

This painting, which is a sort of political poster, is meant to celebrate the day of 28 July 1830, when the people rose and dethroned the Bourbon king. Alexandre Dumas tell us that Delacroix's participation in the rebellious movements of July was mainly of a sentimental nature. Despite this, the painter, who had been a member of the National Guard, took pleasure in portraying himself in the figure on the left wearing the top-hat. Although the painting is filled with rhetoric, Delacroix's spirit is fully involved in its execution: in the outstretched figure of Liberty, in the bold attitudes of the people following her, contrasted with the lifeless figures of the dead heaped up in the foreground, in the heroic poses of the people fighting for liberty, there is without doubt a sense of full participation on the part of the artist, which led Argan to define this canvas as the first political work of modern painting.

38

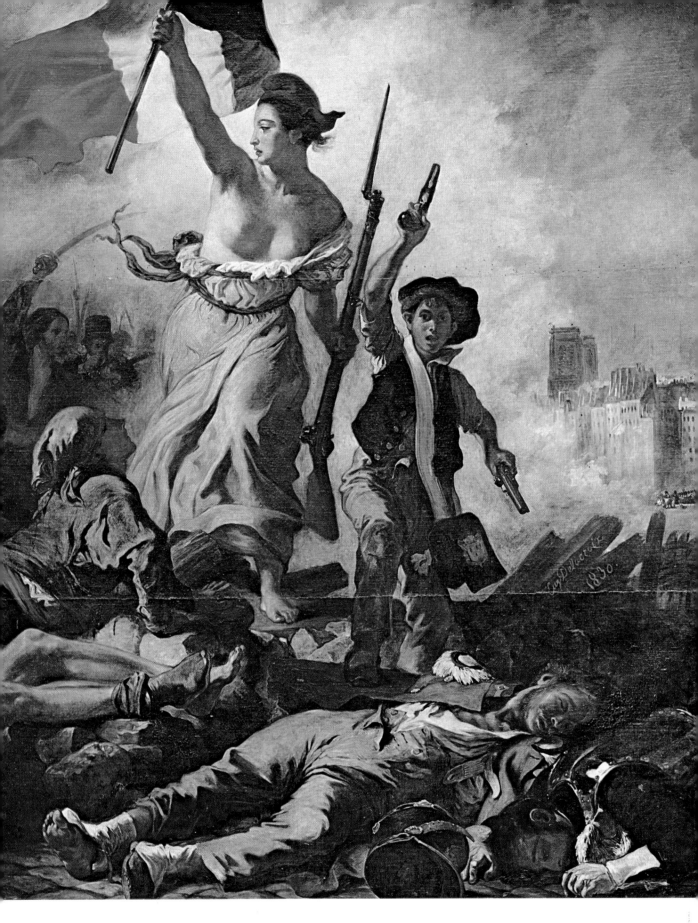

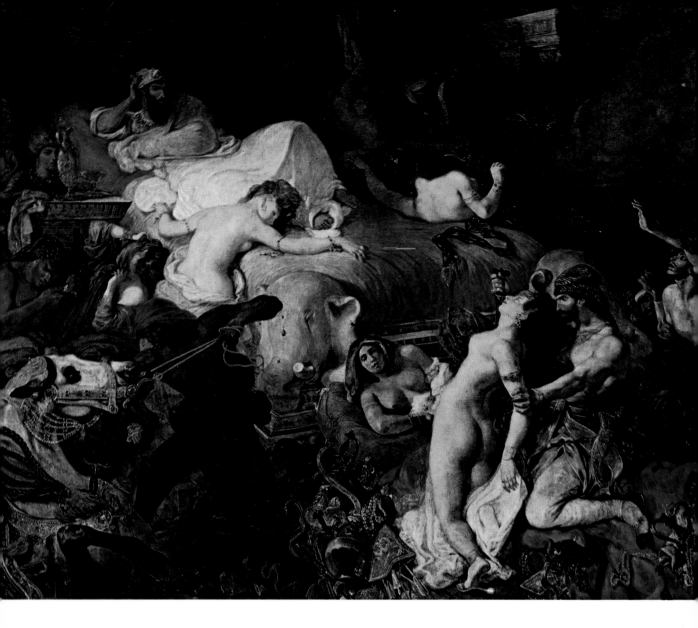

*Eugène Delacroix
(1798-1863)*
Death of Sardanapalos

Exhibited in the Salon in 1827-1828, this canvas was little appreciated because of its errors in perspective and above all because of the confusion which reigns in the foreground. The catologue of the Salon describes it thus: " the insurgents besiege him in his palace.... Reclining on a splendid bed, at the top of a huge pyre, Sardanapalos orders the eunuchs and servants of the royal palace to butcher the women and pages and even his favourite horses and dogs.... Aisheh, the Bactrian woman, because she cannot endure to be put to death by a slave, hangs herself from the columns which support the vault.... ". But Delacroix was not seeking order and precision of detail: his intention was to upset, disturb and exalt the mind of the viewer. The fascination of the Orient, the artist's long stay in Spain and Morocco and his celebration of the exotic and the mysterious have all left their mark on this canvas, as for example in the brilliant colours and in the gleam of the gold which blends with the red of the fabrics. Standing out above all is the sovereign, with his closed, indifferent expression, as he watches, unmoved by the massacre.

Jean François Millet (1814-1875)
The Angelus

Born in the fields, son of a family of farmers, Millet will return to the fields and farmers quite early: together with other painters who, like he, were lovers of nature and simplicity, he chose Barbizon as his last dwelling-place. Millet stands out among many landscape painters in that the protagonist of his art is work: the daily labor of the farmers and the gleaners, bent under the sun or captured in a moment of repose, as are these two figures of farmers praying at the end of the day, leaning on their tools.

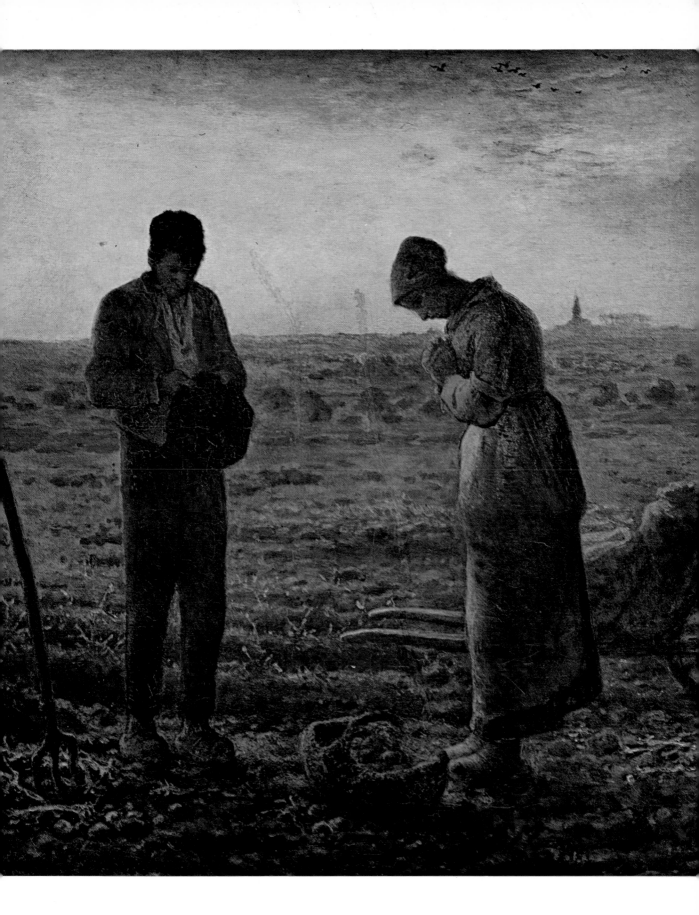

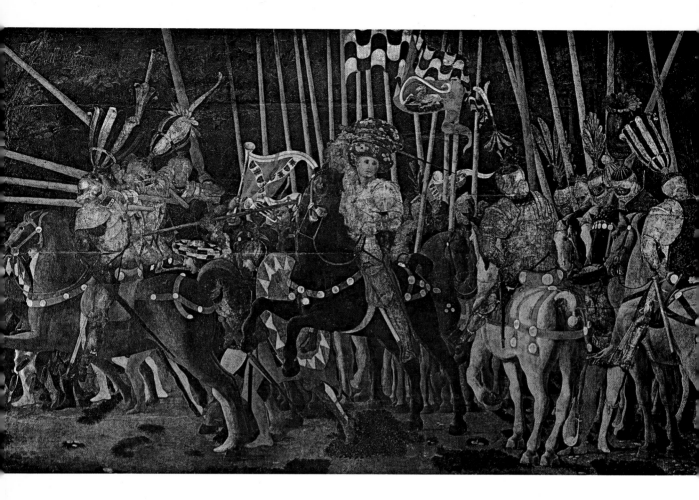

Paolo Uccello (1397-1475)
The Battle of San Romano

Paolo Uccello painted three panels
(now divided between the Louvre,
the National Gallery in London
and the Uffizi in Florence) depict-
ing the three crucial moments in
the battle which took place in June
1432 at San Romano between the
Florentines, under the command of
Niccolò Mauruzi da Tolentino, and
the Sienese, led by Bernardino della
Ciarda. In this panel in the Louvre,
Uccello painted one of the decisive
developments in the battle, the in-
tervention of Micheletto da Coti-
gnola on the side of the Florentines.
The military captain is shown in
the centre of the whole composition,
as the horses paw the ground wait-

ing for the attack. The lances of
the soldiers stand out above the
geometric suits of armour and
elaborate helmets and crests. The
panel (this is the best preserved of
the three, in that it still retains the
silver-plating on the armour) was
painted along with the other two
between 1451 and 1457 for the
Medici Palace. The three are men-
tioned as still being together in an
inventory of the collections of Lor-
enzo the Magnificent done in 1498;
later the Medici Palace was acquir-
ed by the Riccardi family, and the
panels were transferred to the Pa-
lazzo Vecchio where they remained
until the second half of the 18th
century. This panel reached the
Louvre in 1863 by way of the
Campana collection.

Pisanello (c. 1380-1455)
**Portrait of a noblewoman of the
Este family**

There are many theories about the
identity of the woman portrayed
in this panel, painted in tempera
by Pisanello. The amphora em-
broidered on her sleeve seems to
indicate that she is a noblewoman
of the Este family, possibly Ginevra,
the wife of Sigismondo Malatesta,
whereas the sprig of juniper on her
corset and the red, white and green
colours would identify her as a
Gonzaga, Margherita, wife of Lio-
nello d'Este. In any case, whatever
is the name of this young woman,
whose profile stands out against
the bush as if it were engraved,
it is certain that the painting belongs
to the artist's period of full matu-
rity, that it was done towards 1436
or 1438.

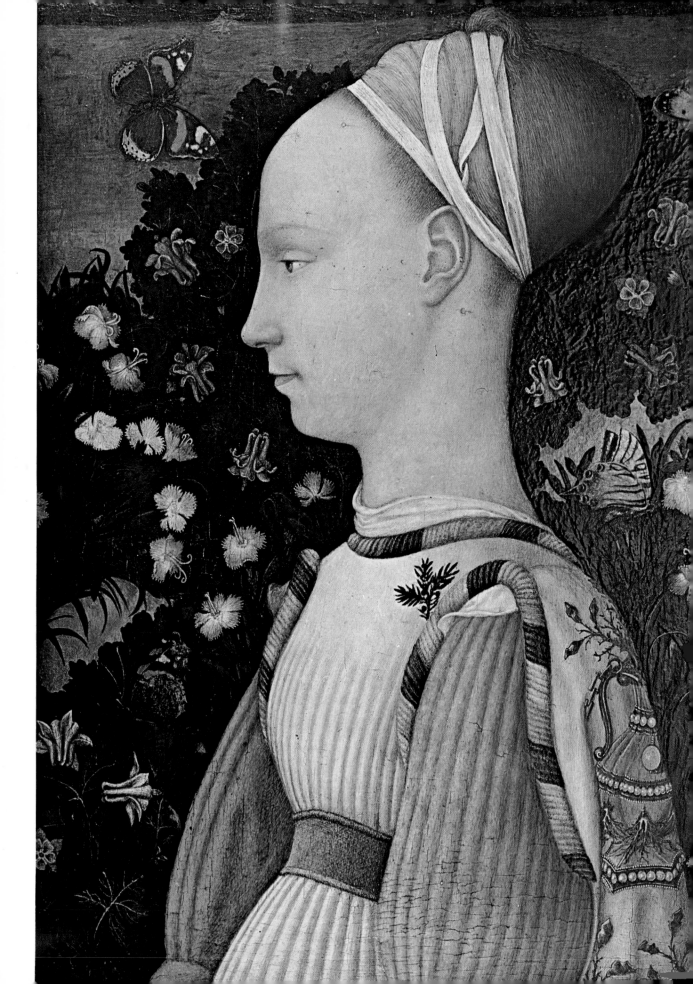

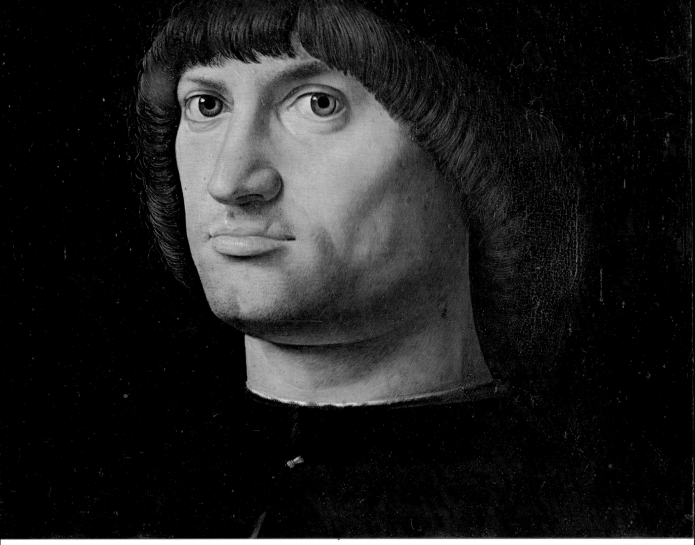

Antonello da Messina
(ca. 1430-1479)
The Condottiere

This portrait of a man, property of the Louvre collections since 1865, takes its title from the resolute, bold expression that animates the canvas. The work is generally dated 1475, the year in which Antonello reached Venice and inaugurated a pictorial tradition which was destined to have a long life in that city.

Andrea Mantegna (1431-1506)
Saint Sebastian

On occasion of Chiara Gonzaga's marriage to Count Gilbert de Bourbon Montpensier in 1481, this canvas was brought to a small city in central France, Aigueperse, where it remained until 1910. Mantegna composed this monumental work making use of massive forms: it demonstrates that he fully understood the spirit of Roman architecture and the Florentine perspective vision. The saint's heroic acceptance of martyrdom redeems the coldness of the composition.

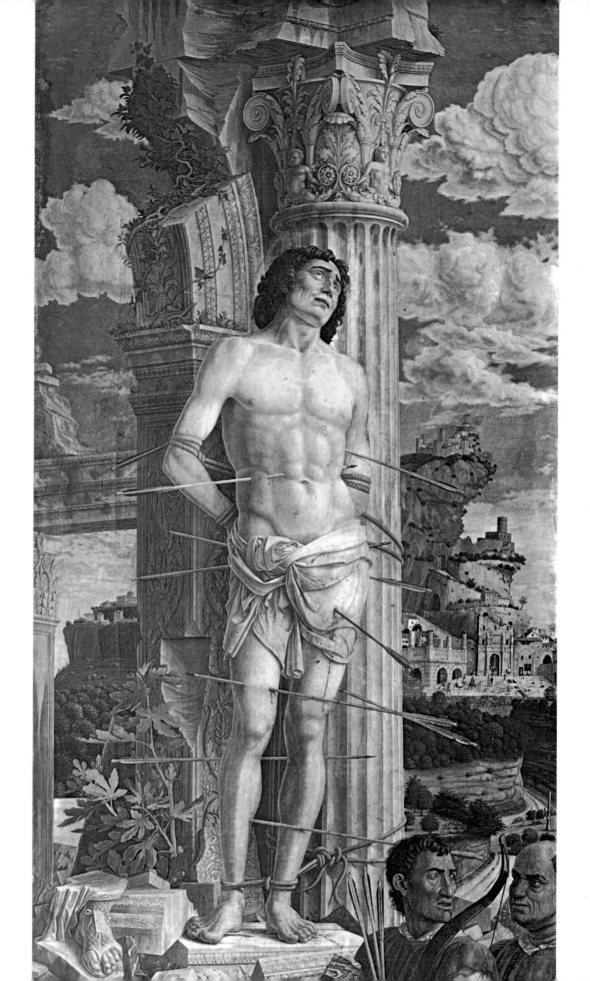

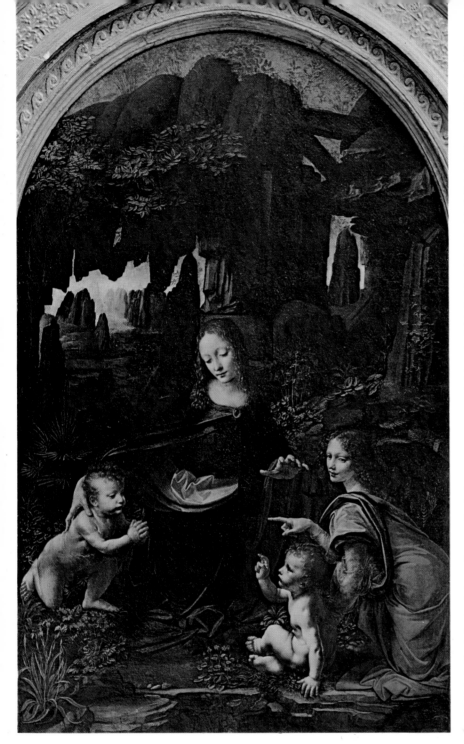

ground, filtering laboriously through the fissures and clefts of the rocks until it illuminates the group in the foreground, with its rigorously pyramidal structure.

Leonardo da Vinci (1452-1519)
Mona Lisa (or The Gioconda)

Reams have been written about this small masterpiece by Leonardo, and the gentle woman who is its subject has been adapted in turn as an aesthetic, philosophical and advertising symbol, entering eventually into the irreverent parodies of the Dada and Surrealist artists. The history of the panel has been much discussed, although it remains in part uncertain. According to Vasari, the subject is a young Florentine woman, Monna (or Mona) Lisa, who in 1495 married the well-known figure, Francesco del Giocondo, and thus came to be known as "La Gioconda". The work should probably be dated during Leonardo's second Florentine period, that is between 1503 and 1505. Leonardo himself loved the portrait, so much so that he always carried it with him until eventually in France it was sold to Francis I, either by Leonardo or by Melzi. From the beginning it was greatly admired and much copied, and it came to be considered the prototype of the Renaissance portrait. It became even more famous in 1911, when it was stolen from the Salon Carré in the Louvre, being rediscovered in a hotel in Florence two years later. It is difficult to discuss such a work briefly because of the complex stylistic motifs which are part of it. In the essay "On the perfect beauty of a woman", by the 16th-century writer Firenzuola, we learn that the slight opening of the lips at the corners of the mouth was considered in that period a sign of elegance. Thus Mona Lisa has that slight smile which enters into the gentle, delicate atmosphere pervading the whole painting. To achieve this effect, Leonardo uses the *sfumato* technique, a gradual dissolving of the forms themselves, continuous interaction between light and shade and an uncertain sense of the time of day.

Leonardo da Vinci (1452-1519)
The Virgin of the Rocks

Begun, according to some critics, in Florence in 1483 but not completed until about 1490, this magnificent work corresponds to another version (most of which was painted by Ambrogio de Predis), now in the National Gallery in London. Leonardo may have received the commission for the work from the Confraternity of San Francesco Grande in Milan; certainly, at any rate, the painting was at Fontainebleau in 1625, and this may permit us to deduce that it was part of the group of works by Leonardo acquired by Francis I. The light in this painting comes from the back-

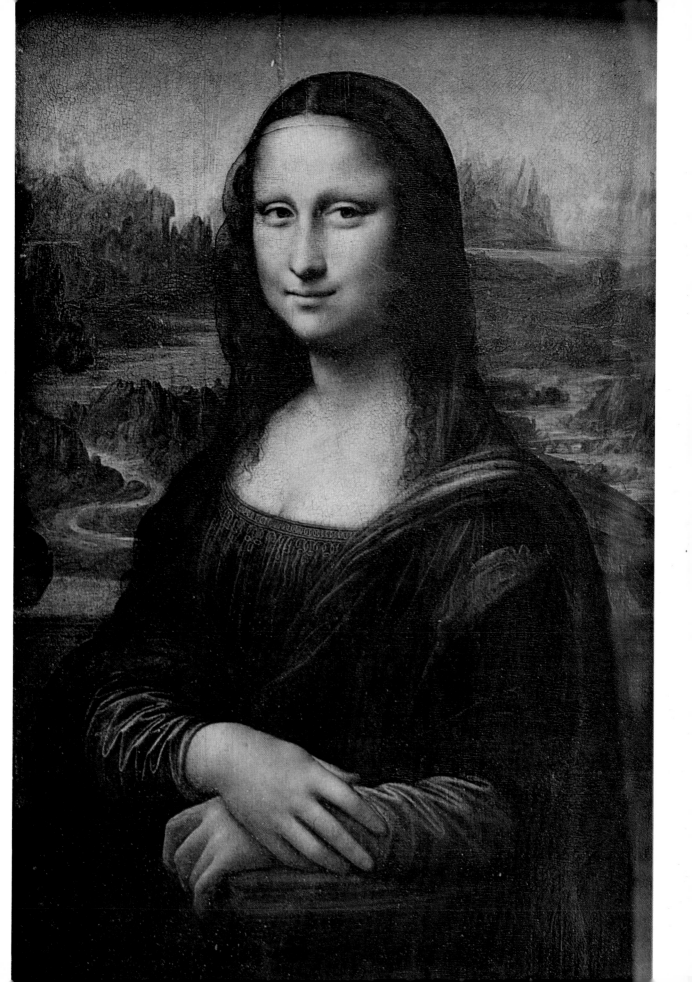

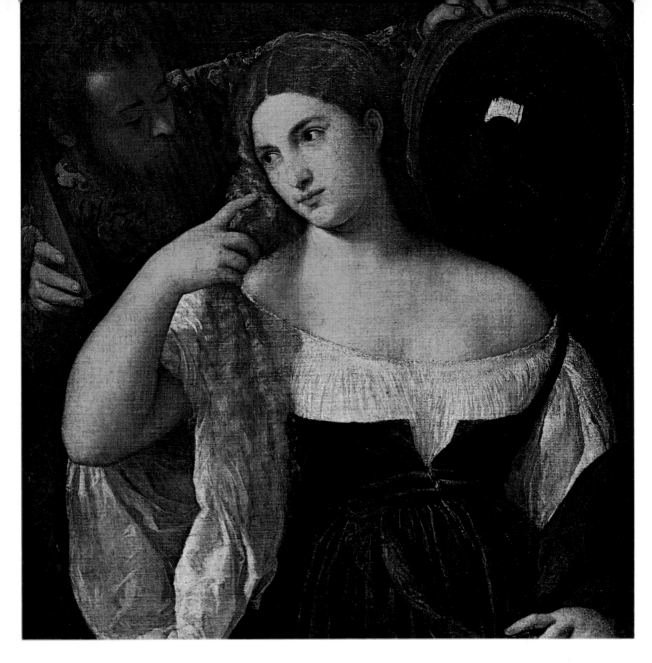

Titian (1488-1576)
Woman at the mirror

This canvas by Titian is usually dated at 1515, that is in the period when the great Venetian painter was still to a large extent under the influence of Giorgione. In fact the warm golden nudity of the woman, the ample white corset opening in numerous folds on her breast and the mass of loose hair are typical of Giorgione. Some critics say that the woman portrayed here is Laura Dianti, the mistress of Alfonso d'Este, while others say that it is Titian's own mistress, but in any case she recurs in many other paintings by Titian.

Raphael (1483-1520)
Portrait of Baldassarre Castiglione

This canvas, dating from 1514-1515, portrays Baldassarre Castiglione, a friend of Raphael and the author of the celebrated " Cortegiano " (The Courtier). Raphael gives us a splendid interpretation of his subject, not only psychological but above all historical, portraying him with a noble, aristocratic espression. The work displays perfect harmony between linear and tonal values: the subject's form is tranquilly contained within the space created and the sober colours reach a perfect equilibrium of grey and gold tones. The pose, a three-quarter bust with the hands linked in front of the body and the figure majestically dressed in velvet and fur, recalls the pose in the portrait of Ginevra Benci and of the Mona Lisa. After leaving Italy, this canvas reached Amsterdam where it was sold at auction in 1639. It became part of the collection of Cardinal Mazzarino, and later entered the collection of Louis XIV.

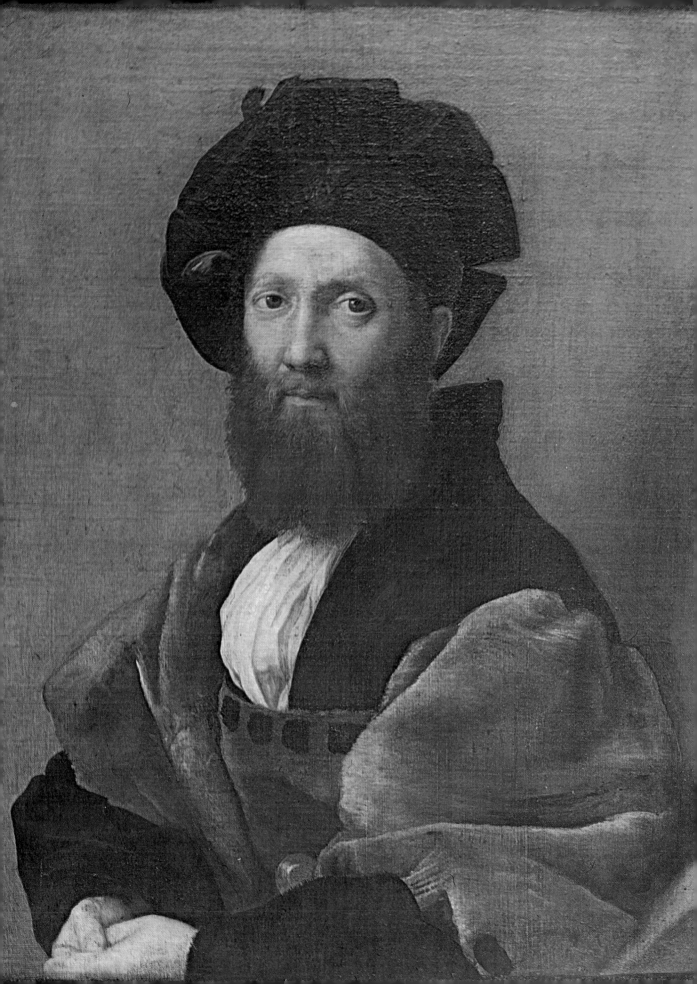

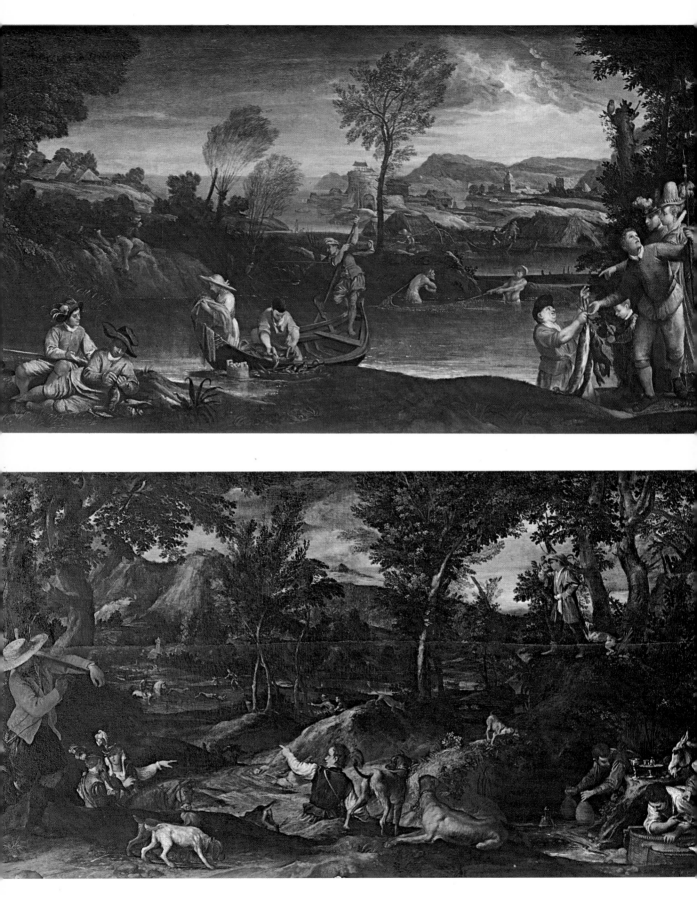

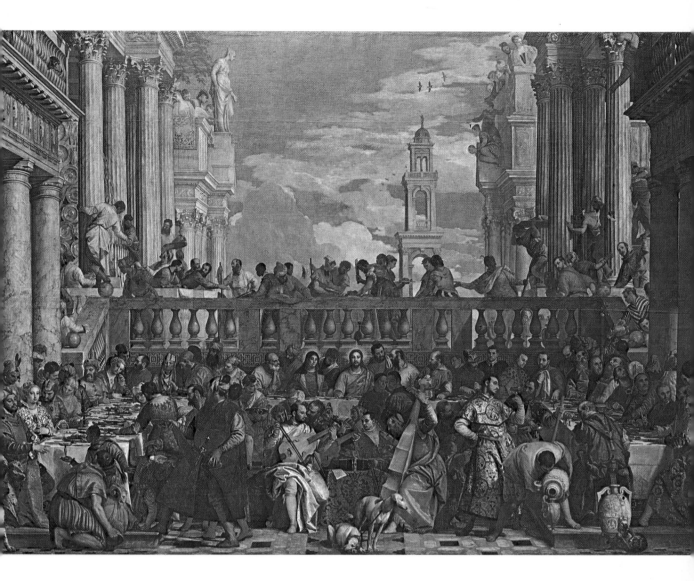

Annibale Carracci (1560-1609)
The Hunt and Fishing

Both given to Louis XIV in 1665 by the Roman prince Camillo Pamphili, the two canvasses reflect a happy moment in the art of Annibale Carracci who, together with his brother Agostino and cousin Ludovico, had founded in Bologna in 1585 a school of fine arts called the Accademia degli Incamminati, the aim of which was to supersede the then empty formulas of Mannerism and seek a more direct contact with nature. The dating of the works can be tentatively put at around 1585, that is, in the artist's first period at Bologna when the reminiscences of Correggio are most felt in his work. His description of the landscape is serene and tranquil.

Paolo Veronese (1528-1588)
The Marriage at Cana

Among the various Suppers which Paolo Veronese painted, this one in the Louvre is one of the finest. In this work, as in the others, the religious episode is no more than a pretext for the artist to describe a magnificent ceremonial occasion in the highly fashionable Venetian society of the 16th century. Within typically Palladian architectural surroundings, which allow the sunlight to enter freely, Veronese paints a crowd of more than 130 figures: princes, merchants, Turks, slaves, jesters, jugglers and dogs. He takes pleasure in describing in minute detail the heavy damask materials, the highly worked silverware, the rich embroidery of the table-cloths. Veronese seems to have depicted among the many guests several important personalities of the Renaissance: Eleanor of Austria, the emperor Charles V, Vittoria Colonna, Mary of England and Suleiman. In the foreground, as if in a place of honour, the musicians are playing: Veronese painted himself at the violincello, Bassano playing the flute, Titian at the doublebass and Tintoretto at the viola. Painted for the refectory of the monastery of San Giorgio Maggiore in Venice, the work was begun in 1562 and completed barely a year later.

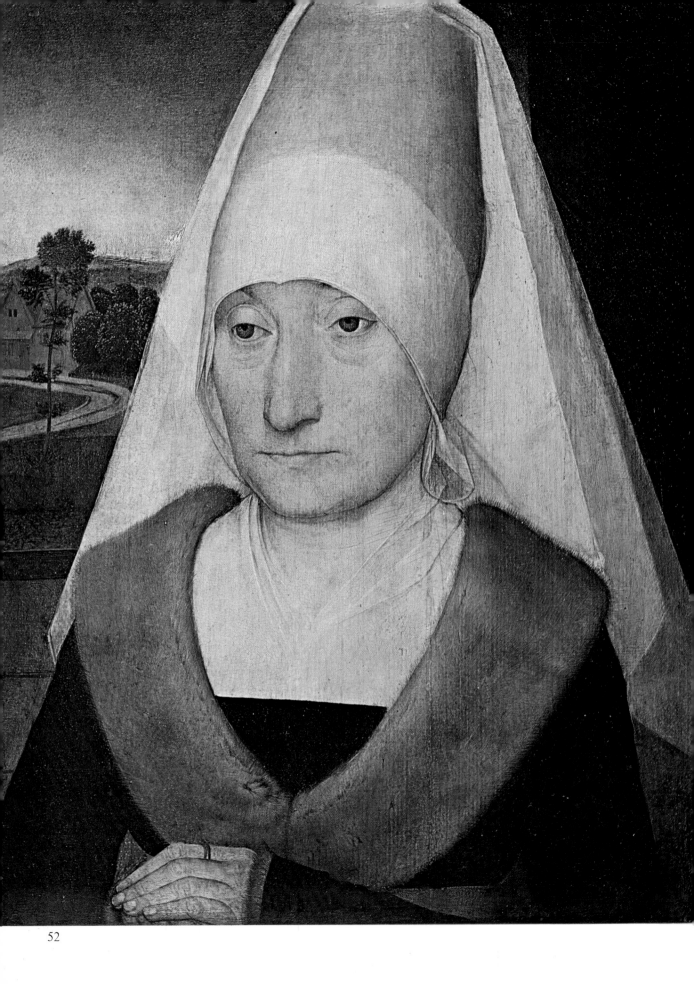

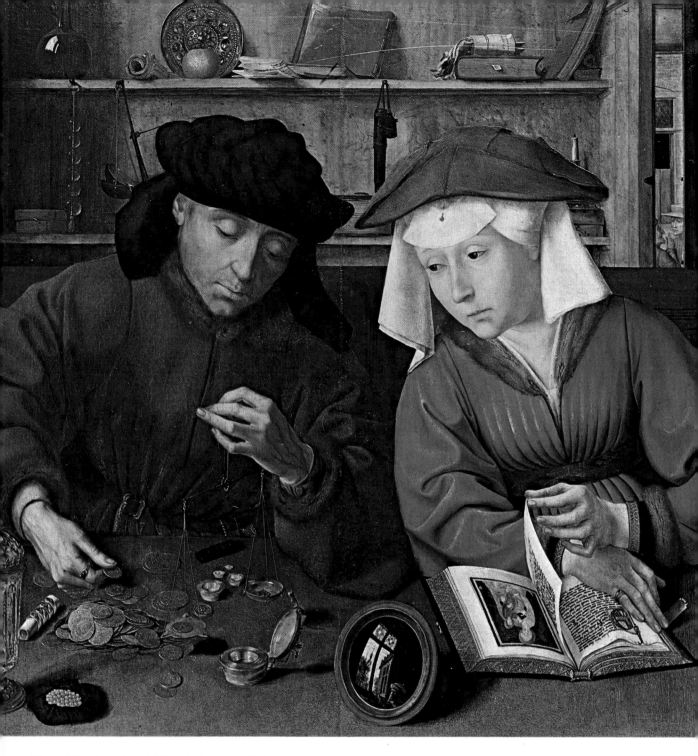

Hans Memling (c. 1433-1494)
Portrait of an Old Woman

This small painting on panel was originally a companion piece to the Portrait of an Old Man (now in the Staatliche Museen in Berlin), and in fact they were sold at auction together by the collector Meazza in Milan on 15 April 1884. Later they were separated and this Portrait of an Old Woman passed through the hands of various private collectors until it was finally acquired by the Louvre in 1908. Apparently painted towards 1470 or 1475, it shows the woman in a half-bust figure, closed geometrically in her dress and placed in front of a landscape according to the Flemish tradition, followed previously by van der Weyden.

Quentin Metsys (1465-1530)
The banker and his wife

This panel has the inscription " Quinten matsyss schilder, 1514 ": it is thus a signed work by Quinten Metsys, an important Flemish artist

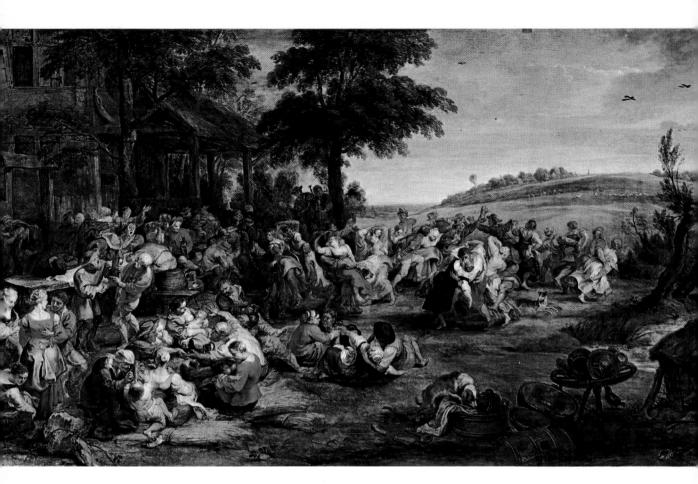

who belonged to the transition between the Middle Ages and the Renaissance and who painted altarpieces as well as non-religious subjects. In Metsys' work, genre painting assumed an importance which until then only works of a religious nature had had. The artist's moralistic or satirical intentions are evident, in this panel as elsewhere in his work. Here he has carefully described the surroundings in the most minute detail and painted the banker as he is weighing coins on a scale. His wife, who has been occupied up until now reading a sacred book, looks up, visibly attracted by the glitter of the gold. The illuminated page of the book thus remains open, while a round mirror (reflecting a window and the landscape outside) stand as a symbol of vanity.

Peter Paul Rubens (1577-1640)
La Kermesse

Perhaps no other artist succeeded so brilliantly as Rubens in combining the colour technique of the Venetians with the Flemish tradition. With him the Baroque school had its greatest triumph: a triumph of colour, of the exaltation of life, an impetus of joy. This highly animated composition belongs to the final period of Rubens' activity, that is to about 1635 or 1638. The recollection of the Kermesses, the dances in the fields, and the open-air feasts painted by Breughel the Elder can certainly be felt: like his predecessor, he liked to create a figure rotating in space and transmitting this movement to the figures beside it and thence throughout the whole group. The entire scene thus becomes a series of whirling couples clutching each other, figures which tend to lose their human identity.

Antony van Dyck (1599-1641)
Portrait of Charles I

A pupil and helper of Rubens, Anthony van Dyck came from the same background as his master but broke away at an early stage to establish his own, highly personal style. Summoned to England by Charles I, he became the official painter of the royal court and was also knighted. During his stay there (which lasted from 1632 to 1641), he did many portraits of the monarch, but this work, painted in about 1635, is the most celebrated and the finest of them. Here Charles I is portrayed as a typical English gentleman after his return from the hunt. The brilliant, almost shrill colours of Rubens are attenuated into softer, more delicate tones: the strong passions of his master have become in the pupil a sort of absorbed psychological introspection. The portraits of van Dyck established a tradition in England which was to put down deep roots.

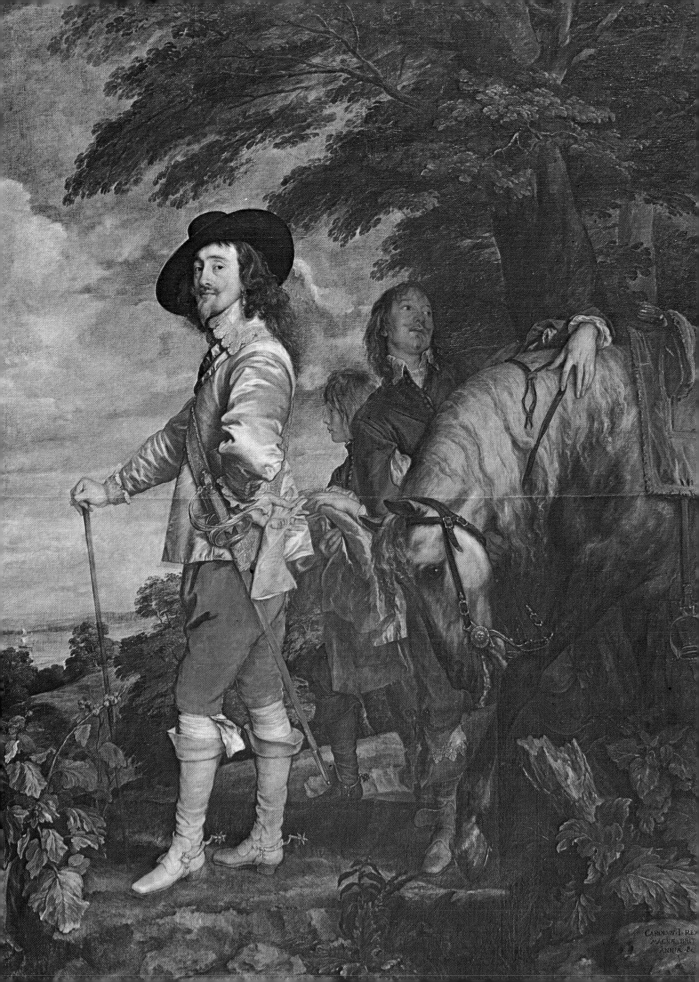

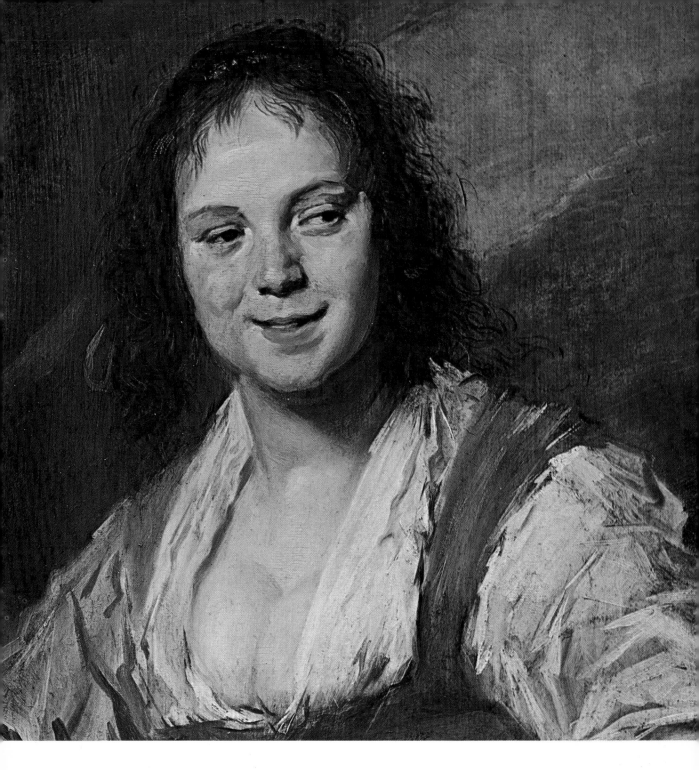

Frans Hals (1580-1666)
La Bohémienne

A Dutch painter, Hals had many contacts with the northern followers of Caravaggio, which led him to depict in his canvasses members of the lower classes, drinkers in taverns, old drunken women. This portrait, usually dated between 1628 and 1630, represents a gipsy woman, dishevelled, smiling, with her corset open at the breast. Hals' brushstroke is extremely rapid and intense, revealing the psychology of the subject. It was part of the collection of de Marigny, brother of Madame la Pompadour, then passed into the Lacaze collection, from which it was left by will to the Louvre in 1869.

Esteban Murillo (1618-1682)
Young Beggar

Murillo, unlike other famous Spanish painters who were among his

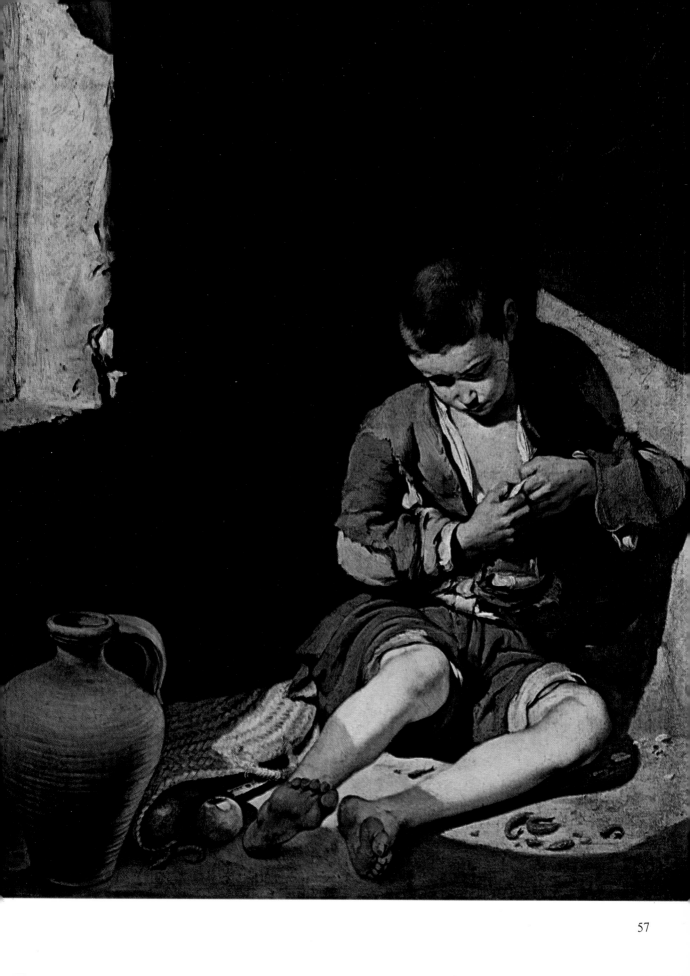

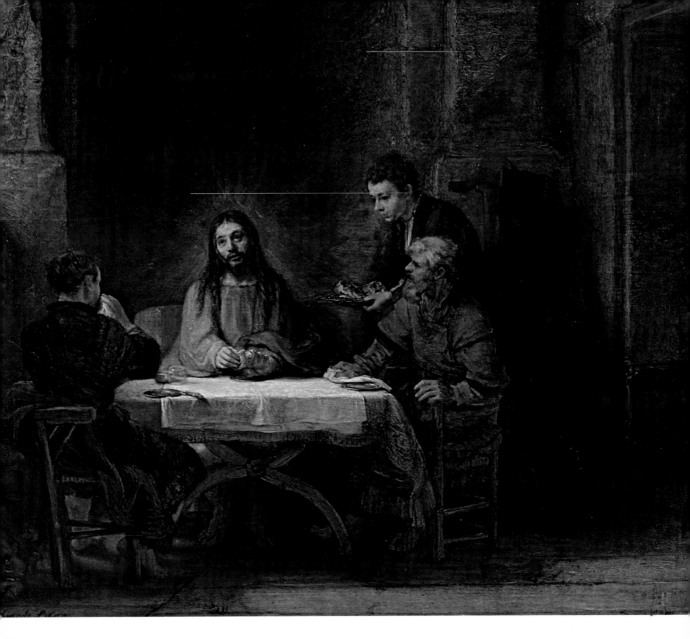

predecessors, kept his distance both from the luxuries of the court and from their gloomy and obsessive mysticism. His faith has a serene quality, untouched by anguish and doubt, while at the same time his scenes of the daily life of the common people are never dramatic or unpleasant. Even in conditions of poverty, in fact, Murillo seeks the most beautiful and delicate aspects, far from the dramatic effects created by the violent contrast between light and shade typical of Caravaggio. Thus this young beggar, despite the rags and tatters of his clothes, is a finely drawn, pathetic figure.

Rembrandt (1606-1669)
The Supper in Emmaus

Painted towards 1648 and acquired by the Louvre in 1777, this Supper in Emmaus is one of the works which belong to the artist's period of full maturity. Here, with extremely simple means, Rembrandt attains to highly dramatic and mystical effects. From the background which is barely sketched in, the face of Christ stands out powerfully, illuminated by a supernatural light. The whole work expresses the sacred and solemn atmosphere of this supreme moment, in which the figures are almost immobilized.

Diego Velasquez (1599-1660)
The Infante Marguerite

Velasquez painted many portraits of the Infante Marguerite, daughter of Philip IV and of Marianna of Austria. This canvas, done in about 1653, may have been one of the royal portraits which the king sent to his sister Anna, Queen of France. The painting belongs to the finest, most mature period of Velasquez' artistic activity at the court of Spain: his colour has reached its warmest tones, his chromatic relations are at their most exact, while the luminous quality which touches the face of the child is not all

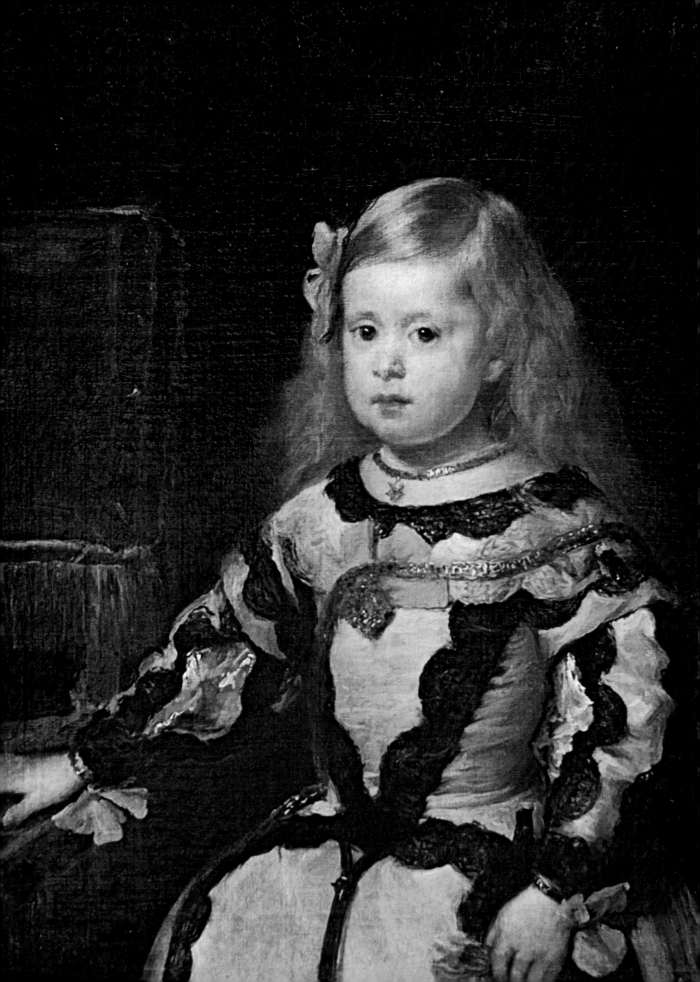

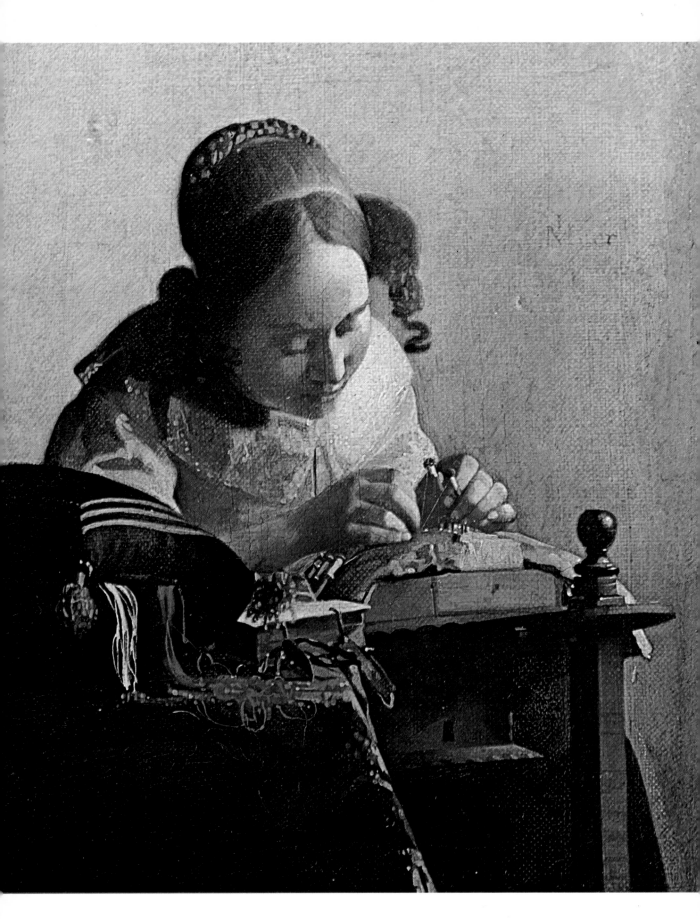

aggressive, but combines smoothly and precisely with the golden yellow mass of her hair. In a job of restoration done in 1659, the words at the top of the painting, " LINFANTE MARGUERITE ", which had been added later, were removed.

Johannes Vermeer (1632-1675)
The Lacemaker

The canvases of Vermeer, a painter forgotten for quite a long time, rediscovered only around 1850, carry us, as if by magic, into the intimate milieu of the bourgeoisie: a simple and never-changing life, made up of small, commonplace, everyday actions. But the perfect harmony among the lights, the volumes and the colors that reigns in Vermeer's compositions (of which this Lacemaker is one of the most well-known and most beautiful) transfigures the simple character of the theme, elevating it to the most exalted spheres of absolute values. The canvas is dated ca. 1664-1665: auctioned in Amsterdam in 1696, it was part of more than one private collection before making its way to the Louvre in 1870.

Francisco Goya (1746-1828)
The Countess of Carpio

At almost the same time in which the passionate, complex mind of Goya was creating the Caprices, the painter was still able to paint serene and delicate works like this portrait of " Dona Rita de Barrenechea, Marquesa de la Solana y Condesa del Carpio ", done between 1794 and 1795. Goya's famous portraits, painted for members of the court circle, represent the other side of his art, a far more relaxed side which is not concerned with the anguish and disasters which war and the hypocrisy and evil of man bring about. Behind the Countess, Goya creates an empty space, which throws into relief the sumptuous black velvet of her long dress, the fine white lace of her mantilla and the large pink rose, realised with a few skilful touches of light.

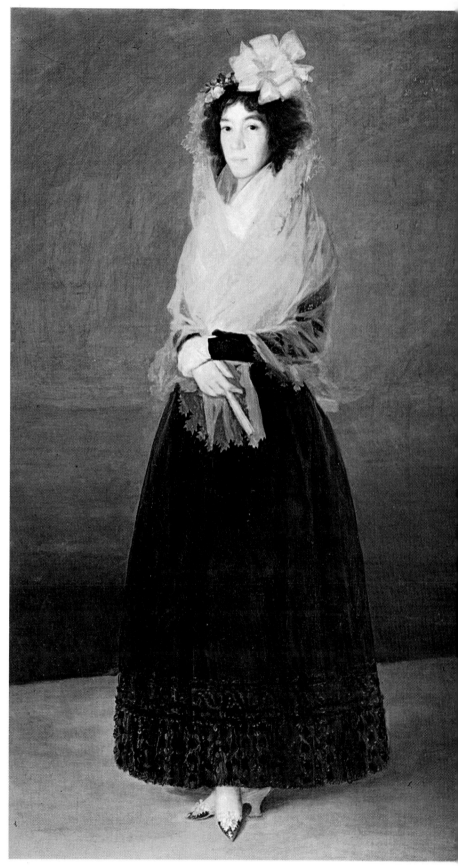

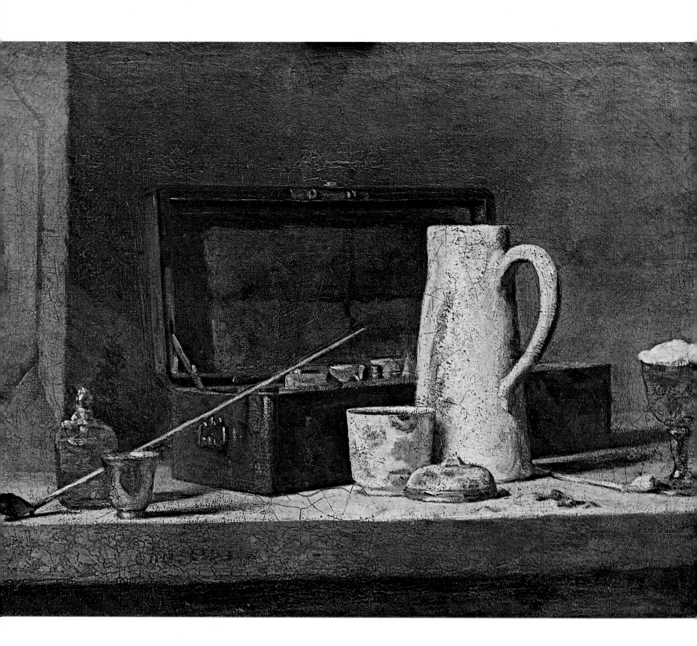

Jean-Baptiste Chardin (1699-1779)
Still-life with Pipe

Under the influence of Enlightenment culture, the little things and lesser experiences of daily life finally took over from the supernatural myths which until then had dominated artistic interests. Chardin took his place in this tradition and was at his most outstanding in the depiction of still-lifes and of simple, commonplace objects. This painting, dated at about 1760 or 1763, is a sober, essential work. The objects are placed according to a rigid criterion, each one suspended in its own precisely determined space, ideally linked to each other, though at the same time each one has its own valid reality.

INDEX

LOUVRE

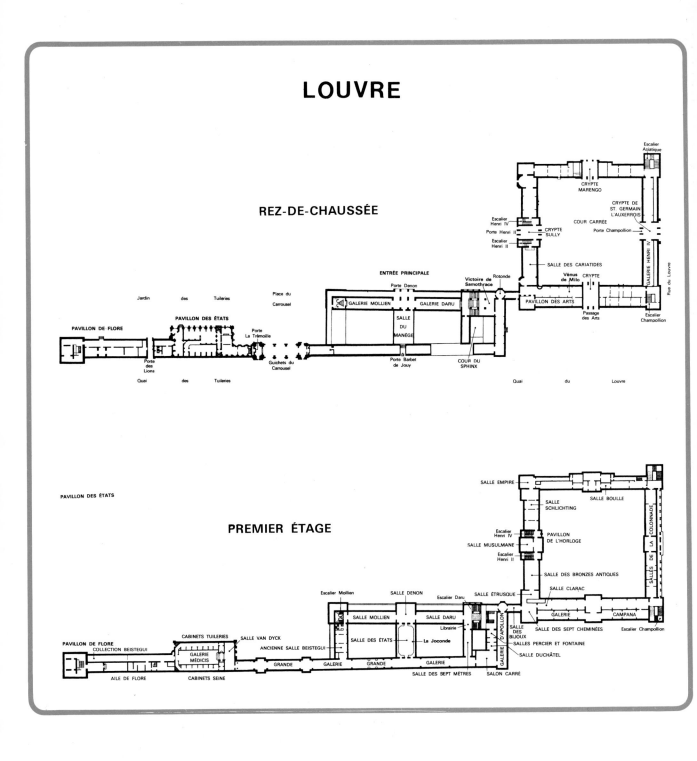

REZ-DE-CHAUSSÉE

Escalier Asiatique

CRYPTE MARENGO

CRYPTE DE ST. GERMAIN L'AUXERROIS

Escalier Henri IV

Porte Henri II

CRYPTE SULLY

COUR CARRÉE

Porte Champollion

Escalier Henri II

GALERIE HENRI IV

Rue du Louvre

SALLE DES CARIATIDES

Jardin des Tuileries

Place du Carrousel

ENTRÉE PRINCIPALE

Porte Denon

Victoire de Samothrace

Rotonde

Vénus de Milo

CRYPTE

PAVILLON DE FLORE

PAVILLON DES ÉTATS

GALERIE MOLLIEN

GALERIE DARU

PAVILLON DES ARTS

Passage des Arts

Escalier Champollion

Porte La Trémoille

SALLE DU MANÉGE

Porte des Lions

Guichets du Carrousel

Porte Barbet de Jouy

COUR DU SPHINX

Quai des Tuileries

Quai du Louvre

PREMIER ÉTAGE

SALLE EMPIRE

SALLE BOULLE

SALLE SCHLICHTING

PAVILLON DES ÉTATS

Escalier Henri IV

PAVILLON DE L'HORLOGE

SALLES DE LA COLONNADE

SALLE MUSULMANE

Escalier Henri II

SALLE DES BRONZES ANTIQUES

SALLE CLARAC

Escalier Mollien

SALLE DENON

Escalier Daru

SALLE ÉTRUSQUE

GALERIE

CAMPANA

Escalier Champollion

SALLE MOLLIEN

SALLE DARU

Librairie

La Joconde

SALLE DES SEPT CHEMINÉES

PAVILLON DE FLORE

COLLECTION BEISTEGUI

CABINETS TUILERIES

SALLE VAN DYCK

SALLE DES ÉTATS

GALERIE D'APOLLON

SALLE DES BIJOUX

SALLES PERCIER ET FONTAINE

GALERIE MÉDICIS

ANCIENNE SALLE BEISTEGUI

SALLE DUCHÂTEL

GRANDE GALERIE

GRANDE GALERIE

GALERIE

AILE DE FLORE

CABINETS SEINE

SALLE DES SEPT MÈTRES

SALON CARRÉ

Printed in the EEC
by Centro Stampa Editoriale Bonechi.